The Campus History Series

WILLIAM PATERSON
UNIVERSITY

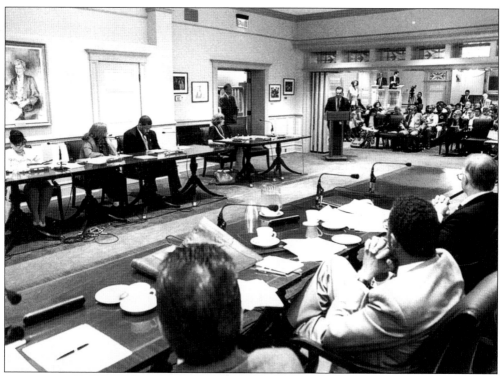

On June 27, 1997, when the New Jersey Commission on Higher Education (above) granted university status to the new William Paterson University of New Jersey, the institution reached one of its most significant milestones. Its evolution over 142 years to that level—as depicted in the pages that follow—is a dramatic saga of significant growth and change. A few days later, faculty, staff, and students celebrated the institution's university status with a special on-campus program. President Arnold Speert (left), who shepherded the college to university eligibility and spearheaded the application for official designation, spoke to faculty, staff, and students about that accomplishment and the future that beckoned.

The Campus History Series

WILLIAM PATERSON UNIVERSITY

VINCENT N. PARRILLO

ARCADIA

First published 2005

Published by Arcadia Publishing,
Charleston SC, Chicago IL, Portsmouth NH, San Francisco CA

Printed in Great Britain

Library of Congress Catalog Card Number: 2004110654

For all general information, contact Arcadia Publishing:
Telephone 843-853-2070
Fax 843-853-0044
E-mail sales@arcadiapublishing.com
For customer service and orders:
Toll-free 1-888-313-2665

Visit us on the Internet at www.arcadiapublishing.com

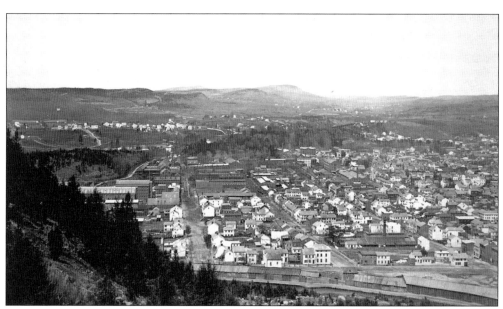

This view of Paterson, *c.* 1865, looks north from Garret Mountain beyond the city in the direction where the university was eventually located. At the time of the institution's founding in 1855, Paterson's population was 16,458. Rapid growth of its locomotive and silk industries had swelled the city's numbers to more than 105,000 by 1900.

CONTENTS

ACKNOWLEDGMENTS

I want first to acknowledge a substantial debt to Kenneth B. White, whose 1967 book *Paterson State College: 1855–1966* was a rich resource for information about that era in the university's history. Special thanks go to Edward A. Smyk, Passaic County historian, for his invaluable assistance. I also want to thank others in the outside community who were so helpful with various aspects of the research: Bruce Balistrieri, Paterson Museum curator; Bruce Bardarik, Paterson Public Library local historian; Joseph Costa, Paterson Museum photograph archivist; and Kathleen Grimshaw-Haven, Passaic County Historical Society librarian. Among those within the academy to whom I am also indebted for their aid in the development of this book are Jeff Albies, Anthony Belford, Gina Buffalino, Anne Ciliberti, Larry Clow, Christine Diehl, Dolores Droumbakis, Violet Flynn, Stuart Goldstein, Judy Linder, Anthony Maltese, Barbara Martin, Robert Seal, Arnold Speert, Robert Wolk, and the *Beacon* and *Pioneer* staffs. Further, I was fortunate to work with a team in the Office of Marketing and Public Relations whose competence, cooperation, and dedication made this effort a most satisfying one, and I express my deep appreciation to Lorraine Terraneo, Robert Verbeek, and Mary Beth Zeman.

—Vincent N. Parrillo

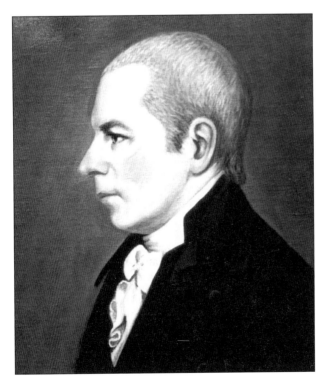

Born in Ireland in 1745, William Paterson came with his family to New Jersey two years later. A graduate of what later became Princeton University, his plan for equal representation by all states at the 1787 Constitutional Convention led to his becoming known as "Father of the United States Senate." The state's first senator until he became governor of New Jersey in 1790, he resigned in 1793 when appointed associate justice of the U.S. Supreme Court, where he served until his death in 1806.

One

THE EARLY YEARS

1855–1950

The university traces its origins to April 1855, when the Paterson Board of Education formally authorized the establishment of a local normal school to begin operations that autumn. The previous year, Paterson had launched its citywide system of free public schools. Until then, most children did not attend school at all, while those who did either attended private and charity schools or else received instruction from local schoolmasters to whom their parents paid tuition. This expansion of the public schools resulted in a shortage of competent teachers, which prompted the city's superintendent of schools, Col. Andrew Derrom, to call for a normal school comparable to those already existing in New England and New York. Paterson Normal School thus began as an entity to provide professional training, first, for practicing teachers and, two decades later, for prospective teachers as well.

Initially offering only evening classes and then adding Saturday morning classes, the normal school had only a part-time student enrollment consisting of teachers employed by the city of Paterson. Until 1875, the normal school functioned as this appendage to the city's public school system, requiring teachers to complete a three-year sequence of courses in English, mathematics, geography, philosophy, and pedagogy. In 1875, city officials reorganized the normal school into a preservice teacher-training program instead of an in-service one. This shift in emphasis made the institution similar to normal schools elsewhere.

Now called Paterson City Normal School, the institution expanded its curriculum in 1891 from one year of full-time studies to two years. By the 1920s, educators and government officials had reached consensus that teacher education should be a state responsibility, so local educators and citizens lobbied for the state to assume control over the normal school. In 1923, Paterson City Normal School became Paterson State Normal School. New students entering in 1929 found another change: a three-year curriculum. In April 1937, a four-year curriculum and degree-granting program was in place. Also, the name changed to the New Jersey State Teachers College at Paterson, a name that was kept until 1958. During its first century, the institution bore several names, but all identified its raison d'être: teacher education.

As the following pages will attest, the institution had numerous homes during its long history. Four times it escaped proposals that it be abolished due to low enrollments and public funding difficulties, first in 1860 and then again in 1933, 1938, and 1939. Through wars, depressions, and major societal changes, the institution and its curriculum evolved, but it remained committed to its original mission: preparing the teachers of tomorrow.

In its first few years of existence, Paterson Normal School held its classes in old School No. 1 in the city's center. In the 1870s, normal school classes switched to School No. 6, at Summer and Ellison Streets, where high school classes were also held. Here, it was somewhat of an appendage, with its graduation exercises part of the high school commencement.

————CLASS OF '90————

Carrie S. Amirnux,
Margrethe C. Arentzen,
Annie Atkinson,
Martha E. Duryea,
Mary L. Driscoll,
Minnie M. Demarest,
Annie T. Doremus,
Annie L. Ferguson,
Martha Ferenbach,
Alice A. Hartley,
Ruth Hartley,
Cora E. Hughes,
Eva Helms,
Charlotte Hutcheon,
Lizzie A. Kincaid,
Agnes G. Kerr,
Gertrude G. Kinsella,
Ethel L. Meyers,
Annie T. McKowne,

Loretta McKenna,
Emelene A. McClory,
Alice Mallon,
Fannie R. Morgan,
Nettie C. MacAlister,
Alice M. McGeehan,
Mamie G. Nichols,
Jessie A. Robertson,
Charlotte W. Simpson,
Cora M. Paige,
Edith M. Tuttle,
Bertha E. Tompkins,
Annie Teal,
Helena M. Tynan,
Maggie Vreeland,
A. Janette VanHouten,
Laura VanRiper,
Lizzie A. Winans,
Eleanor J. Watson,

F. Josephine Sullivan.

PATERSON NORMAL

COMMENCEMENT

FRIDAY EVENING, JUNE 20TH, 1890,

DIVISION ST. REFORMED CHURCH.

The class of 1890 was the first to hold its commencement separate from the high school exercises, with graduates assuming the expense of renting the Division Street Reformed Church auditorium. This foreshadowed the normal school's complete detachment from the high school and its affiliation with an elementary school as a practice teaching center.

That detachment and elementary school affiliation began when Paterson Normal School became a two-year institution. Its students had the advantage of observing the elementary school classes of School No. 6, where it still shared its facilities with the high school. In 1902, long after the normal school had relocated, fire consumed this building.

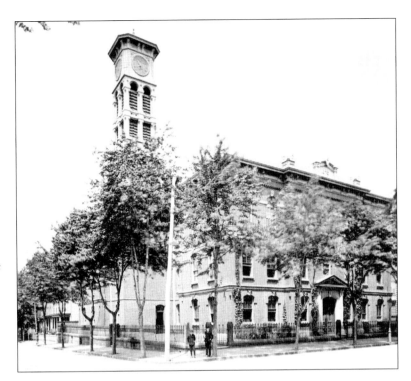

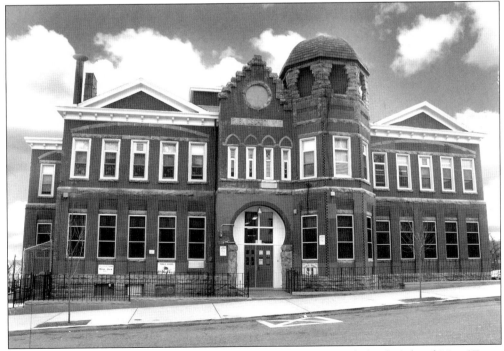

In the early 1890s, the institution's next home was the newly built School No. 17, on North Fifth Street, two miles from today's campus. The building, which still survives, also contained a practice, or model, school. The faculty taught not only the normal school classes but also K–4, as well as serving as critic teachers of the practice teachers.

When overcrowding made School No. 17 untenable, Paterson City Normal School and its affiliated practice school moved again, in 1895, this time to the new School No. 1. It was at this location that new staff qualifications were implemented, requiring strong capabilities in three areas: elementary classroom teacher, critic teacher, and instructor of normal school curriculum subjects.

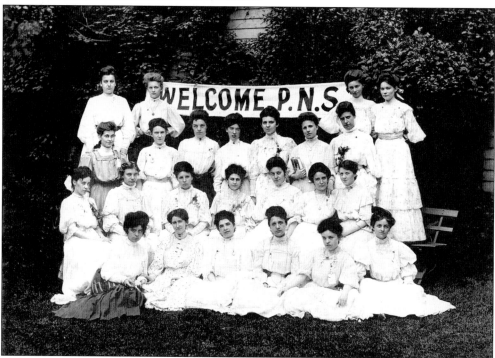

The June 1903 graduates of Paterson City Normal School, like all others during the years of the city school's existence, were entirely female. They were some of the first students whose teachers in a two-year program both instructed them and taught in a model school where the students could observe teaching methods.

During his 1905–1925 tenure as principal of the normal school, Dr. Frank W. Smith presided over the smooth transition from a city to a state normal school. His 1915 report stressed the need for studying the socioeconomic background of Paterson's residents to make the normal school curriculum more effective for teacher preparation purposes.

The pleasure of your presence is requested

at the

Junior Promenade

of the Paterson Normal School, given to the

Senior Class

by the

Junior Class

Friday evening, May twenty-ninth

eight-thirty o'clock

at

Orpheus Hall

1914

A popular tradition during normal school days was this social event. Today, it is called the senior prom. Juniors, however, sponsored the dance to honor the graduating class and to mark their upcoming transition to seniors. Orpheus Hall in Paterson was a popular facility where many public social events were held.

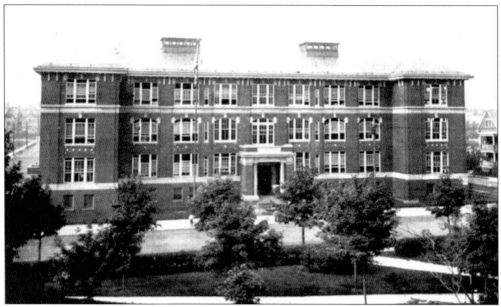

By 1910, the normal school had outgrown School No. 1 and moved to the second floor of another new school, School No. 24, on 19th Avenue and East 22nd Street, just off Market Street. Here it remained for 40 years, during which time it evolved from a city to a state normal school and developed a strong presence as Paterson's only institution of higher education.

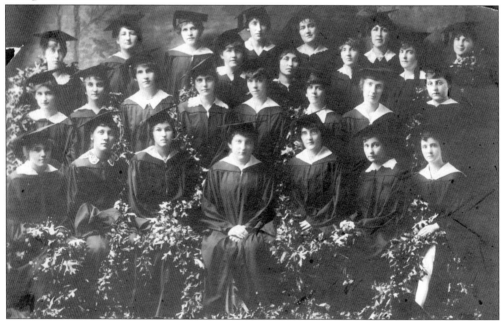

This graduating class of 1916 typifies the twice-yearly programs held in the School No. 24 auditorium. Prior to the awarding of diplomas, it was commonplace for seniors to present original essays, read from literature on education, demonstrate teaching methods or elements of normal school training, and provide instrumental and vocal selections.

12

In 1928, Dr. Roy L. Shaffer, the next principal (1925–1933), suggested a new physical facility for the growing normal school, only to see the Depression cause the cancellation of a land deal for that purpose. Before his transfer to Jersey City State Normal School in 1933, Shaffer successfully rallied students, alumni, and civic leaders in blocking the state from closing the Paterson school.

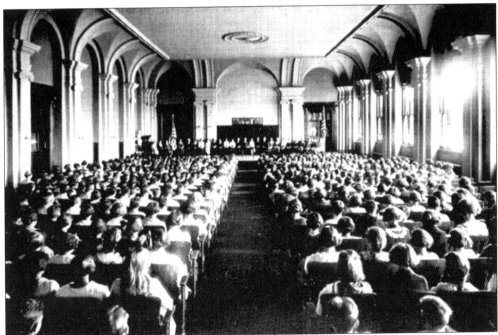

Daily, student-run assemblies took place in mid-morning until the 1930s. Lasting about 45 minutes, these programs involved children in the demonstration school or included "addresses by persons of note on up-to-date topics." The assemblies then became a weekly affair until lack of seating capacity at the new campus ended these programs.

13

Almost all male students were members of the men's chorus in 1933, when this picture was taken, a time when total enrollment was less than 250 students. This group appeared at school assemblies, gave spring concerts, and standing on the stairway of Quackenbush's, a major Paterson department store, serenaded holiday shoppers with Christmas carols.

In the early years of the New Jersey State Normal School, numerous special interest clubs, honorary and professional societies, and various social groups came into existence with either official or semiofficial status and a faculty advisor. Some chose Greek letters for their identity. Here, members of the Kalon Society pose for their 1933 yearbook photograph.

With a looming funding crisis and its very existence threatened, the normal school's principalship remained vacant for two years. Dr. Edgar F. Bunce served as acting principal (1933–1935), commuting once or twice a week from Trenton, where he was state supervisor of teacher training, to handle various administrative matters.

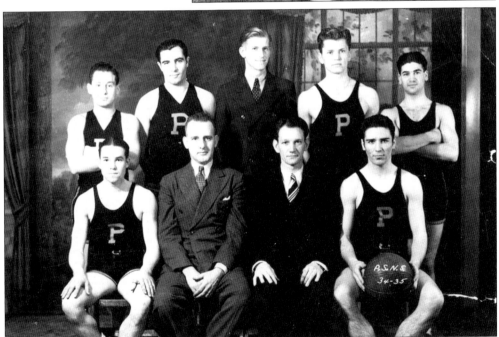

Prior to remodeling the School No. 24 auditorium in 1938 (which then also served as a gym), all basketball teams, including the 1934–1935 team, played home games on various courts throughout Paterson. Because it required fewer men, who were in scarce supply as students in those years, basketball was one of the first normal school sports.

Dr. Robert H. Morrison brought extensive expertise in teacher education when he was appointed Paterson's new principal (1935–1937). The energetic Morrison revised the curriculum, inaugurated college-wide educational field trips, altered physical facilities at School No. 24 to make the building more appropriate for college students, and worked consistently to give the normal school its status as a collegiate institution.

Even after his promotion to state director of teacher education (and in 1945 to assistant commissioner of higher education), Robert Morrison continued to help the college compete equally with other schools. In 1956, recognizing his lasting imprint on the institution, the Paterson State Teachers College Board of Trustees named the new library and administration building after him.

Support the
Basketball
Team

Read
The
Crier

The Paterson State Beacon

Published by the Students of Paterson State Normal School

VOL. 1, NO. 1 MONDAY, NOVEMBER 2, 1936 PATERSON, NEW JERSEY

Masked Dance
Tops All Records

The Hallowe'en Dance held Friday night proved beyond all doubt that our freshman class knows how to run successful dances. A new high in sociability at Normal School was reached by this informal dance.

Largely responsible for this happy situation was the good sportsmanship of all those attending the dance. The special dances were entered into in good spirit and th' Broom Dance, the Nantucket and the other special dances were the cause of a great deal of fun for all participants. Many of the costumes were very colorful and imaginative. Prizes in the various costume contests were awarded as follows:

Olga and George Shuflat—most attractive couple; Mary McGuirk—the most original; George Keller—most characteristic. The judges were Miss Jackson and Miss Jeffries.

One of the outstanding features of the affair was the evident real enjoyment with which the faculty members took part. The students were actually thrilled to see them "cutting up" with all the enthusiasm which is generally expected only of students. Refreshments in keeping with the occasion were served; everyone appreciated the doughnuts and cider.

The freshman class, the freshman committee responsible for the dance and Mr. Williams, the freshman advisor, are to be heartily congratulated on providing a grand evening for all concerned.

Library Plans
Active Season

Since the opening of school, the Library has ordered 200 new book titles, most of which are now on the shelves. The new titles include a large number of fiction and non-fiction best sellers, several of which are mentioned in the "Book Notes" of this paper. The list also includes interesting titles in the fields of literature, education, social life, guidance, science, interior decoration and personnel. There are also several new …

WANTED: A New School Picture

The picture reproduced herewith was taken under Principal Smith's regime back in 1918. It has served long and faithfully as the official picture of our school. For eighteen years it has appeared in Handbooks, City Newspapers, and other School and outside publications. It is due time to honor old age and faithful service by retirement, but before this can be accomplished we need a satisfactory substitute.

This paper will publish next month the best recent picture of the school building. If the picture is good enough, it may possibly be adopted as our official school picture, thereby relieving the aged but active current "official." If you camera enthusiasts have not yet taken a picture of the building, do so now. We really need a good picture of our school. Will you help us get one?

Dean White Reviews
General College Course Plan

The educational plan whereby a Normal School or Teachers College offers general college courses for the first two years to students who do not intend to become teachers, is new to New Jersey. It is not, however, a wholly untried plan. A similar arrangement has met with unusual success at San Jose and Fresno State Colleges in California, and at the Teachers Colleges in the middle west.

There is every reason to believe that the reorganization of Paterson State Normal School to include instruction in general college courses marks a progressive step which may be considered of great significance in the improvement of higher education in New Jersey.

Students who are primarily interested in general college courses recognize a number of specific advantages attendant upon this arrangement, in contrast to a federally operated emergency junior college as operated for the last two years in this building. First, they know they are attending a permanent institution established over …

eighty years ago to meet lasting educational needs rather than needs arising from economic depression. Second, they attend classes during the regular school day. Third, because the school is administered by the State Department of Public Instruction; credits may be transferred to many other institutions without difficulty. Fourth, the program of student activities is much more varied and on a better financial basis. Fifth, they are assured of uninterrupted instruction of high quality.

For all of these advantages, the tuition is lower than in any other school offering standard college courses in this vicinity. The opportunity to work on the college-aid program makes it possible for any serious student to meet nearly all of his college expenses.

The response to the new program this semester has been most gratifying. Teacher education students, general college students, and the entire staff may feel proud to have a part in inaugurating this new educational

(Continued on Page Three)

Field Trips Planned

WEDNESDAY, NOVEMBER 18
NAMED AS DATE

At the last faculty meeting, Wednesday, November 18, was decided upon as the date on which all-day field trips will be conducted by the various departments and classes. There will be no meetings of the classes regularly scheduled for that day.

Although many different places of interest were suggested no definite decisions were made as to what places would be included in the program. The Planetarium, the American Museum of Natural History, the Metropolitan Museum of Art, the Federal Reserve Bank in New York City, the New York Stock Exchange, the Book Fair at Rockefeller Center, Valley View Sanitarium and Washington's Crossing and the Barracks (Trenton area of the Revolutionary War) were the most highly favored of the suggestions advanced.

At the next meeting of the faculty final decisions will be made regarding this important matter. Watch the "Crier" for further information in regard to final plans for the day of field trips.

Extension Courses
Prove Popular

The Paterson State Normal School Extension Division has registered for the fall semester of 1936-37, 344 students. Seventy different towns are represented. Two classes are given off the Campus. Dr. Clair S. Wightman travels to Pompton Plains every Monday afternoon and Mr. W. George Hayward, who is Supervising Principal of the Mahwah Schools and who, during the past summer taught at the N. Y. State Teachers' College at Oswego, makes a trip to Belvidere every Tuesday.

It seems that most of the students are interested in beautifying their classrooms, according to the number of registrants for the Interior Decorating course, Mr. Charles Henders, who is a graduate of Stuttgart College and Berlin College and manager of an interior decoration firm with offices in Paterson, has 86 in his class.

Mr. Williams' course in Modern European History has an enroll

(Continued on Page Four)

This first edition of the *Beacon*, on November 2, 1936, marked the arrival of a true college newspaper. Its editor-in-chief was James Houston, a member of the class of 1940, who later became chairman of the Education Department. Houston was a prime mover in securing state approval for a graduate program in 1955, as well as in reactivating soccer as a college sport in 1959.

17

As the first college president (1937–1954), Dr. Clair S. Wightman guided the institution past proposals to close it in the late 1930s and then through the postwar years and GI Bill veterans enrolling and on to its relocation to the current college campus. He was a major force in developing a graduate program, new physical facilities, and higher faculty salaries and in promoting interracial and interreligious harmony.

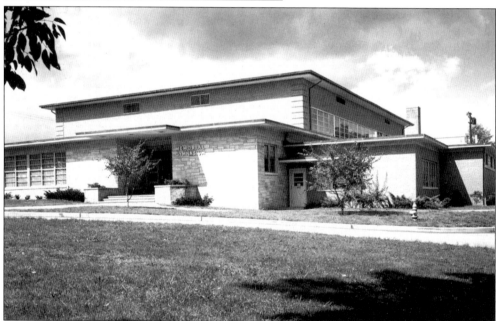

After Clair Wightman's retirement, the New Jersey State Board of Education approved naming both the college athletic grounds and the new gymnasium after Wightman in recognition of his efforts to build these facilities and expand the athletic program. The *Beacon* commented that Wightman's spirit "exemplifies the purposes and traditions of our college."

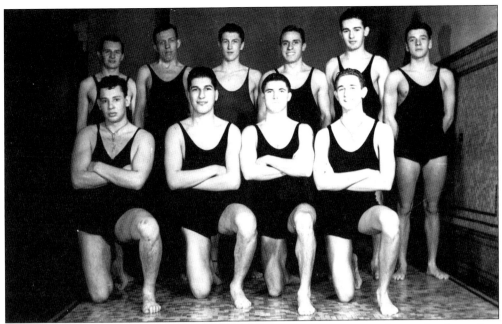

Members of the 1939 swim team pose proudly at the Paterson YMCA pool, where they held practice and competitive meets. Students also used the Y for social events. The pool area served as a locale for coed splash parties, and the ballroom—resplendent with reflecting light from a rotating mirror ball—offered a scintillating, romantic evening.

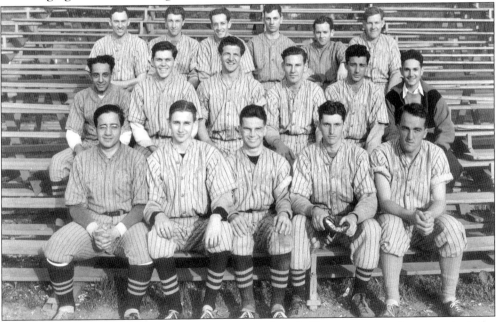

Until the college moved to its new campus, baseball was a secondary sport at the normal school. Teams, such as this one in 1939, had practice sessions and games at various public parks, often at Paterson Eastside Park. Some years it was difficult to recruit enough men to field a team, and once World War II erupted, the sport was discontinued until the 1950s.

19

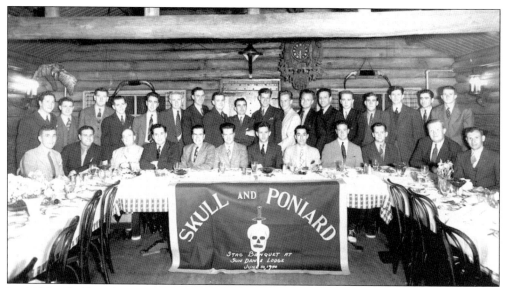

In 1933, Skull and Poniard came into existence as the school's first fraternity. This June 10, 1940, photograph shows a reunion banquet at the Sun Dance Lodge. President Clair Wightman stands sixth from the left in the rear. From 1955 until the mid-1960s, official recognition of all fraternities and sororities was denied, but it was subsequently restored.

Wendell Williams, the school's first African American player (shown here with his 1941 basketball teammates and coach), led his teams to conference championships in 1940 and 1941 with his high scoring and tenacious defensive play. He was twice named to all-conference teams, and his team defeated the touring Mexican national basketball team.

Lack of a campus setting did not deter students from many forms of outdoor coed activities. In 1941, students pose for the camera on the ice of Barbour's Pond at Garret Mountain Reservation. When the school moved to Wayne, Gaede's Pond—another popular ice-skating area—became the home locale for winter parties.

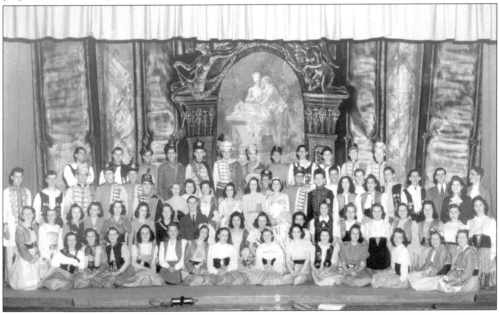

For 11 years the glee club and the dramatic society combined their talents to perform primarily in Gilbert and Sullivan operettas. Presented on two or three consecutive nights in the Paterson Eastside High School auditorium, they involved many students and faculty. This 1941 production of *Waltz Dream* was the last, as the program fell victim to the war years.

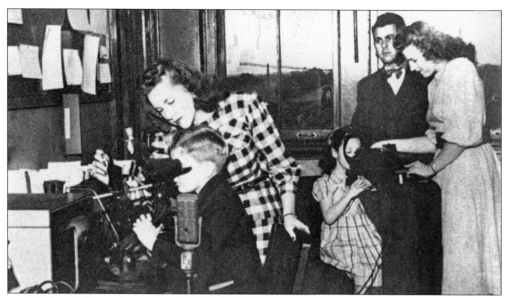

In 1944, Prof. Mark Karp (second from right) initiated a diagnostic and remedial reading clinic. In the clinic's second year, Dr. Wightman reported that 39 children from 25 school systems were examined, with reports sent to principals of the schools the children attended. The clinic thrived after the college moved to the new campus, and a master's degree in reading soon began.

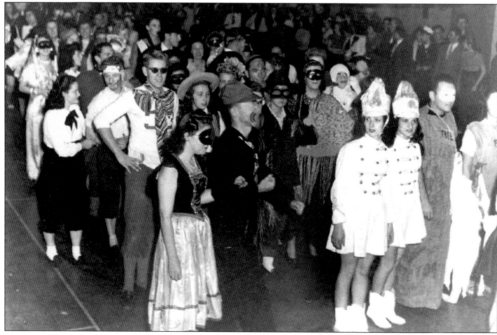

Dances have a long history, from normal school days to university times. This October 30, 1947, scene shows the popular annual event the Freshman Frolic, hosted by the freshman class for upperclassmen and faculty. At the grand march, judges picked the funniest, prettiest, and most original costumes. Those without costumes paid a 30-cent fine.

Two

THE COLLEGE
ON THE HILL

1951–1960

President Clair S. Wightman, in his July 1945 annual report, urged the state to set aside funds for the purchase of a campus site and a building program to meet the college's continually expanding needs. Alumni, local civic groups, service clubs, and newspapers united to champion this cause and persistently lobbied the New Jersey State Board of Education, through its president, Gustav A. Hunziker, a respected Paterson attorney who served on the panel for nearly a half-century. For three years the process slowly moved forward, through the board and the legislature. On May 12, 1947, Gov. Alfred E. Driscoll signed an appropriation bill allocating $1 million for a new building at Paterson State Teachers College (PSTC).

State board members quietly visited sites in the Paterson area suggested for the new campus. They seriously considered the Barbour estate, on the slope of the Broadway hill, site of the Paterson Orphan Asylum, before settling on the more spacious and collegiate-appearing Hobart estate. Sen. Charles K. Barton of Passaic County, who sponsored all bills on the college's behalf, introduced another measure to authorize the purchase of land, equipment, construction and alteration of buildings, and various land improvements. Governor Driscoll signed the bill on April 5, 1948, and on August 13, 1948, the state acquired title to the Hobart estate.

Another development tempered the good news. Other legislation in 1947 had created a division of Rutgers University in Paterson and authorized the integration of that branch with PSTC. In September 1948, that integration became effective at School No. 24 when Rutgers opened an office and began offering evening classes in general education, as PSTC had done since 1936. Limited to teacher education courses, the Part-Time Division saw its enrollment drop by half. Furthermore, a 1949 state board resolution eliminated even daytime offerings of such courses by PSTC.

Uncertainty arose about whether the new campus was to be shared by Rutgers and PSTC or was to remain the site of one institution. Given the three attempts to shutter PSTC in the Depression-era 1930s, that concern was real. When the college relocated to the Wayne campus, Rutgers officials decided to move from School No. 24 to Central High School's annex, which stood across the street from the county courthouse in the center of the city.

Much needed to be done before the college could transfer its activities to the new campus, which it finally did on October 18, 1951. Even then, makeshift arrangements were necessary, as a steel shortage delayed completion of the water tower to provide sufficient pressure for essential rest rooms, and the lack of lighting in the parking area dictated that late afternoon and evening classes remain at School No. 24 for the fall term. Nevertheless, a new era had begun and the enthusiasm of faculty, staff, and students about the new campus was contagious.

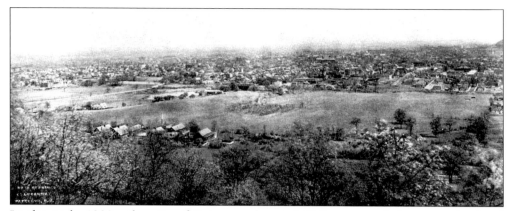

In the early 1930s, the city of Paterson donated 118 acres and the normal school nearly relocated to Preakness Hill by the county-owned Valley View Tuberculosis Sanitarium. This picture appeared in the 1932–1933 catalog as the school's new site, but hopes were dashed by the Depression, and the land reverted back to the city for veterans' housing.

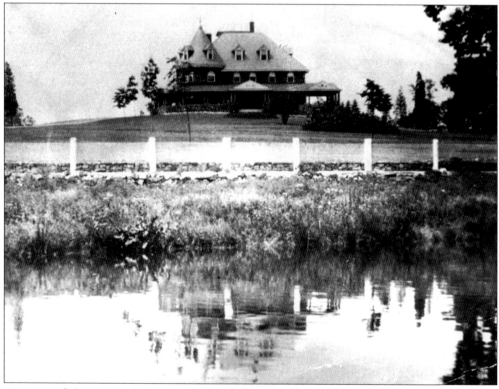

Owners of the property that became the college's new campus, the Hobart family acquired the adjoining estate of Paterson silk dyer Robert Gaede, with its pond across Pompton Road. The house was demolished, and the site eventually became Parking Lot 3. For much of the 20th century, the pond remained a popular fishing and ice-skating locale.

The Old Barn, as students and staff called it, was another building on the Hobart property that only remained for a few years. Situated approximately where the Atrium now stands, this stone building served as a garage, storage facility, and work area for the maintenance crew, in much the same manner as it was for the Hobart family's groundskeepers.

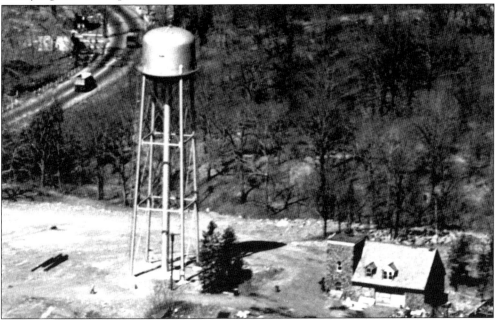

The new water tower was erected adjacent to the Old Barn to provide necessary water pressure. Completion delays because of a steel shortage kept classes in School No. 24 until November 26, 1951. Even then, lack of lights in the parking area forced late afternoon and evening classes to remain at the old school location for the rest of that semester.

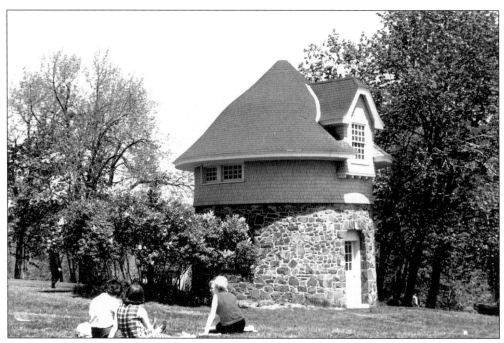

The Round House was only a water-pumping station, but for a dozen years its quaint architecture made it a pleasant setting for relaxing and other outdoor activities, including commencement. College officials lobbied in vain to preserve it but lost out to Trenton bureaucrats in the early 1960s. It was razed to make way for Raubinger Hall.

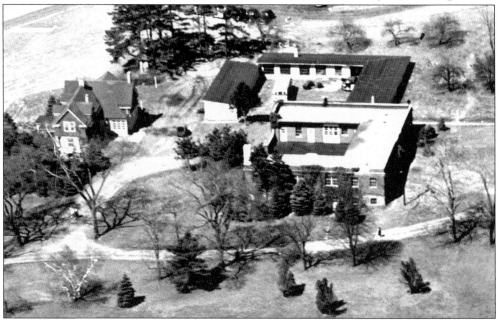

This aerial view shows other buildings that yielded to the growing needs of the college. To the left is a two-family residence in which the Hobart groundskeepers lived with their families until the 1960s. To the right are the stables, which were in such excellent condition that the college used these facilities for other purposes for almost 15 years.

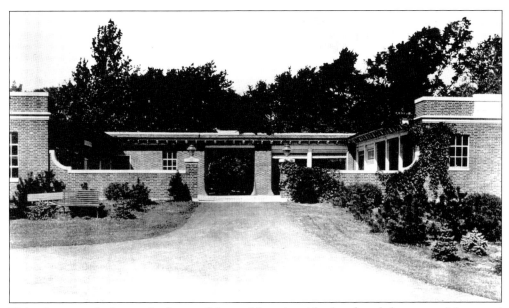

This photograph shows the front of the stables, the side that faced the groundskeepers' house. Styled after the brick stables in such horse-breeding states as Maryland and Virginia, the building became the first Student Union, complete with a cafeteria and bookstore. Both the stables and residence were razed to clear the area for the new Shea Center Auditorium.

The Hobart family used this building as a laundry and garage that housed their carriages, cars, and groundskeeping equipment. Not surprisingly, the building was called the Coach House, a name it still retains. In the 1950s, however, when the maintenance staff continued to use it as a garage, it was known as North Hall.

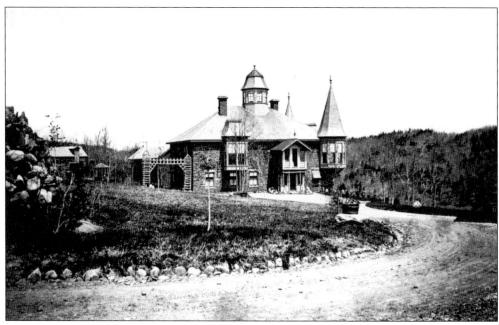

John MacCulloch built this fieldstone castle in 1877 at a cost of $25,000. When MacCulloch returned to his native Scotland, Jennie Tuttle Hobart, the widow of Garret A. Hobart (the vice president of the United States, who died in 1899), purchased the estate at an auction in 1902 and deeded Ailsa Farms to her son as a Christmas present.

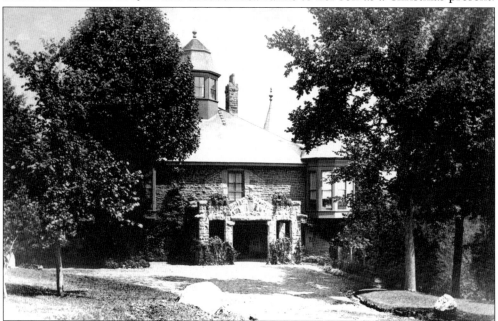

This front façade alteration was a first step in what followed. In Washington, Jennie Hobart served as hostess for President McKinley, whose wife was in poor health. After her husband's death, Jennie Hobart returned to her Paterson home on Carroll Street. Enjoying a rich and rewarding life as a philanthropist and community activist, she moved here in 1940.

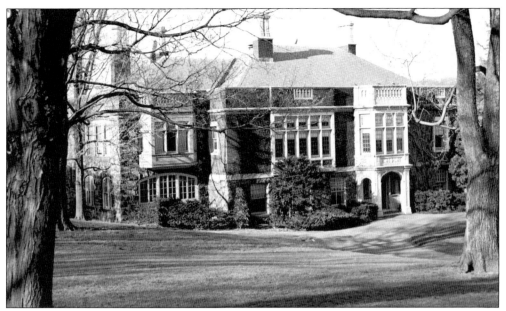

In 1915, Garret Hobart Jr. began four years of extensive remodeling and expansion of the castle into a Tudor manor house. The octagonal towers were removed and replaced with a new stone entranceway surmounted by a bay window. The second-floor stonework exterior was replaced with brick; leaded glass casement windows replaced the old sash windows.

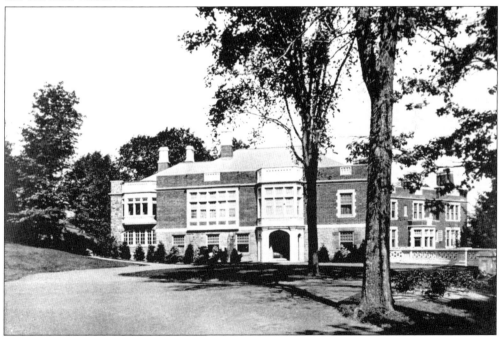

A three-story brick wing on the east side expanded the house to 40 rooms. When the college moved in, this building—renamed East Hall and then Haledon Hall and now Hobart Manor—originally contained administrative offices, three classrooms, and a library, its books voluntarily brought from School No. 24 by students in their own cars.

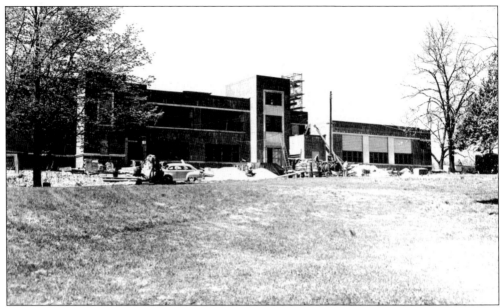

Before the college could move from School No. 24, a new classroom building was required. Hunziker Hall—named after attorney Gustav A. Hunziker, president of the New Jersey State Board of Education—contained 15 classrooms, a little theater that held about 200 people, a few offices, a locker room in the basement, and other lockers in the corridors.

The spirit of sharing an exciting new venture manifested itself on Arbor Day in April 1952, when the entire student body and faculty devoted part of the day to cleaning up the campus. In 1950–1951, they made frequent visits to the new campus and held a dance, dinner meetings, a conference, and an alumni card party at the Manor House.

30

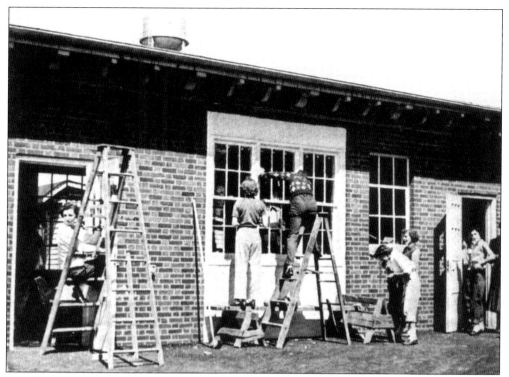

Another example of the cooperative spirit that permeated the new campus was that of the many students who donated their time and labor to paint and spruce up the old brick barn. The $20,000 in remodeling costs to convert the building into a student center and bookstore came from student funds.

Once completed, the new Student Union quickly became a popular hangout and social center. This view shows the bookstore entrance at a rare moment—no students are present. Most times, however, as any graduate from the 1950s and early 1960s will tell, this building resounded with the sounds of conversations and laughter.

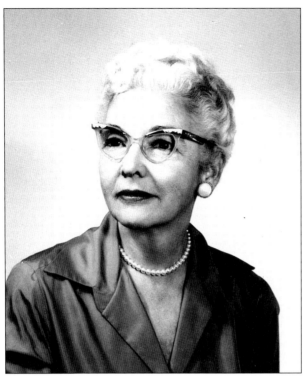

Marion E. Shea was the first woman president (1954–1966) of a New Jersey state teachers college. Assistant Commissioner Robert Morrison presided at her inauguration, the first in the history of the college, and State Commissioner of Education Frederick Raubinger offered brief remarks. Under her leadership the college went through a vigorous period of enrollment growth and facility expansion.

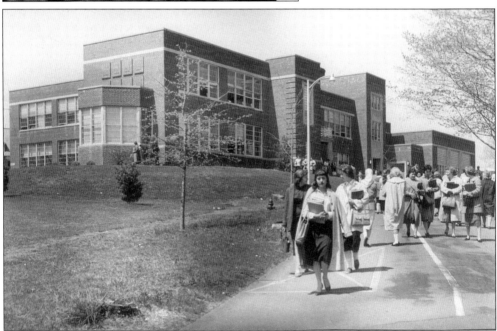

The roadway between Hunziker Hall and the Student Union building (and the parking lot beyond) was the most heavily trafficked thoroughfare on campus until the mid-1960s. In the front center of Hunziker Hall was a carillon—a gift of students, alumni, and friends—that chimed at midday and also played during the nearby outdoor commencements.

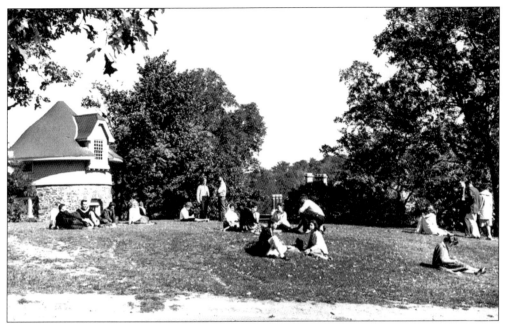

The grassy knoll between Hunziker Hall and East Hall (the Manor House with its chimneys visible in the background), punctuated by the aesthetically pleasing Round House, provided an ideal parklike setting for students to congregate. This open expanse and the Round House were lost with the construction of Raubinger Hall.

Adjacent to the grassy knoll was another popular place to gather before and after classes: the open space between Hunziker Hall and North Hall (the Coach House). This area still attracts clusters of students although not to the same degree, given dispersion of students over a wider area and the more conducive grounds around the Machuga Student Center.

The new campus provided an opportunity not possible at School No. 24: outdoor classes, as seen in this 1950s photograph by Hunziker Hall. This tradition still continues as some instructors move classes outside to take advantage of pleasant weather. The challenge for them, then and now, is to be as scintillating as possible to overcome the distractions.

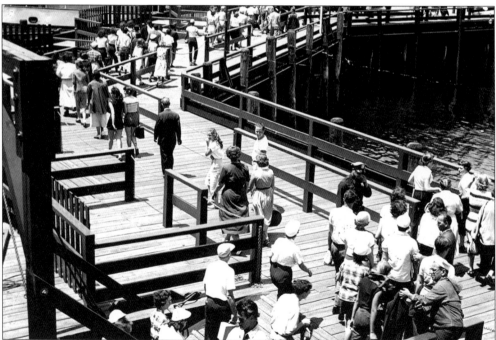

Bus rides to Lake Hopatcong or Rye Beach for end-of-year student/faculty picnics began in normal school days. Officially named Shaffer Play Day in 1937 after the former normal school principal, the event transformed into a chartered boat ride at Rye Beach in the 1950s (shown here) and a trip to Bear Mountain in the 1960s.

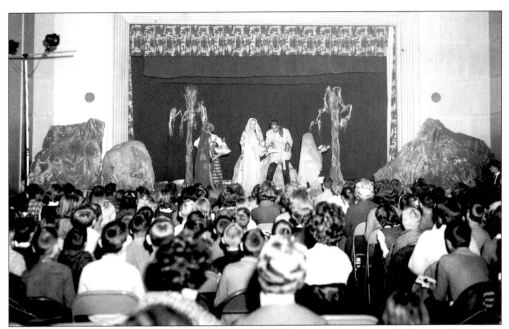

Hunziker Hall's auditorium served as the locale for the production of plays in the 1950s and early 1960s, before the construction of Shea Center for Performing Arts. Afterwards, this space was converted into the Black Box Theatre for performances of workshops or smaller shows, plays without sets, or other experimental pieces.

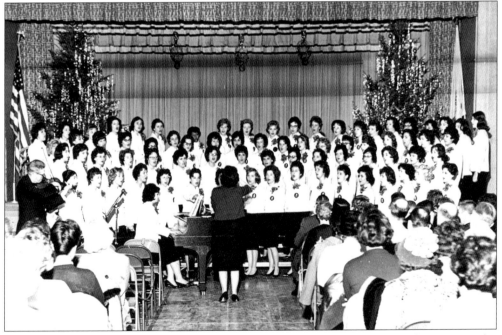

An annual Christmas concert and a spring concert were also regular features in the Hunziker auditorium, continuing a tradition that began in 1934 with a special music group known as the Madrigal Singers. These concerts, involving large numbers of students, consistently attracted large audiences of students, family, and other guests.

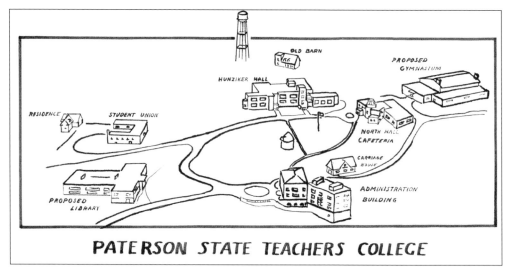

PATERSON STATE TEACHERS COLLEGE

The sketch by history professor Raymond Miller illustrates the proposed new library and gymnasium, as well as buildings existing in 1951, the year the aerial photograph (below) was taken of the new campus. Included are the Old Barn, near the water tower; the caretakers' house, to the left; the stables, converted into the Student Union; the barely discernible Round House, between Hunziker Hall and the administration building; the partly hidden Carriage House; and the Coach House, then known as the North Hall cafeteria.

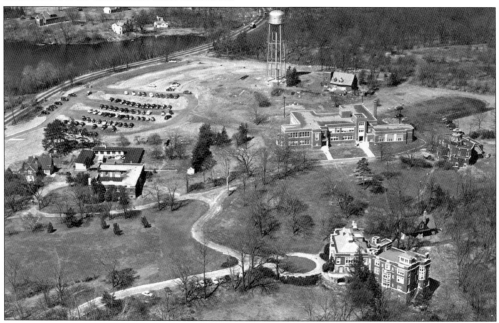

Facing a 20 percent increase to 1,000 students in September 1957, President Shea, with the help of business manager Frank Zanfino, a member of the class of 1949, secured six barracks that had been used for veterans' housing. Cut into sections and moved from West Orange to the campus, the barracks were reassembled and equipped with space heaters. Five were used as classrooms.

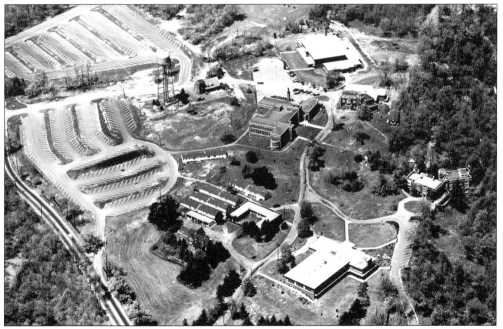

Five classroom buildings stood next to the Student Union building, with the sixth—a snack bar handling the overflow from Wayne Hall—to the right of North Hall. Each little red schoolhouse had three non-soundproof classrooms, which served their purpose until 1963, when they were demolished for construction of Shea Center.

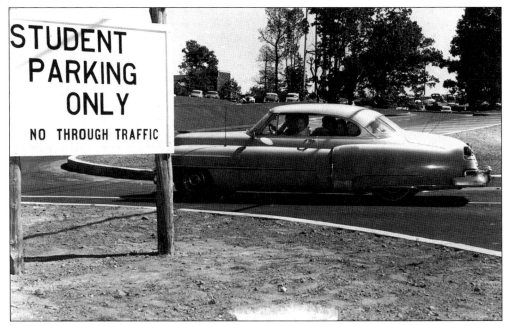

Adventures in parking is a chapter in virtually every commuting student's college life story. Although the parking lot in this picture offers many empty spaces, it was usually just as difficult to find a place to park in the 1960s as it often is today. Cars were longer, too, so maneuvering into a tight space offered another challenge.

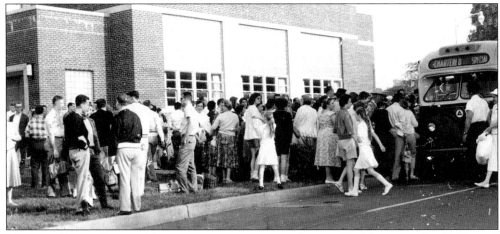

Chartered buses from Public Service were an integral part of field trips in the 1950s and 1960s, as part of the outdoor education program, for Shaffer Play Day, or for special trips to places such as historic sites or museums. The front of Hunziker Hall commonly served as the pickup and drop-off point.

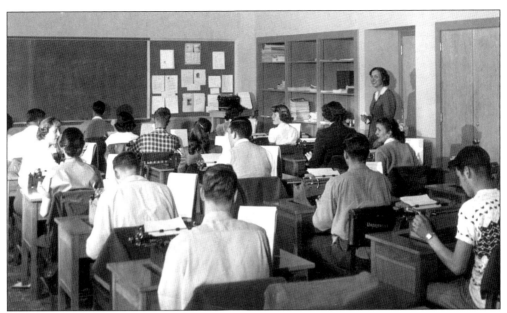

Business courses had long been popular general college electives, and in 1943, Paterson began offering a business education program that attracted about 100 majors each year. After the state board of education decided in 1953 that all secondary school education would be at Montclair, the program ended and Paterson business faculty were transferred.

In September 1954, the food service building, officially named Wayne Hall, opened and a culinary and service staff began providing midday hot and cold lunches. Most faculty and staff took advantage of the opportunity to dine with colleagues in a separate dining room, so it was common for them then to run into almost everyone they knew.

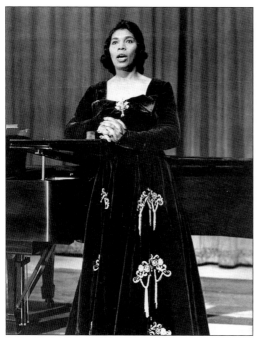

Once the gymnasium opened in 1956, a series of enrichment programs presented luminaries such as Robert Frost (top right), Margaret Mead, and Pearl S. Buck. Begun in 1959, the Evening Series—the forerunner of today's Distinguished Lecturer Series—offered (clockwise from the lower right) Eleanor Roosevelt, Jose Greco, and Marian Anderson. (Greco photograph courtesy Gjon Mili/Stringer/Time & Life Pictures/Getty Images.)

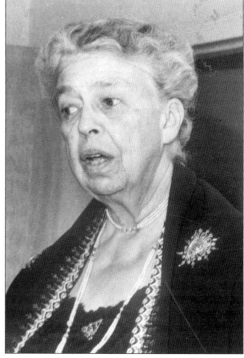

In late spring or during senior week, the Senior Faculty Dinner was held off campus at popular locales such as Donahue's, Essex House, Friar Tuck, or Mayfair Farms. Food, music, some brief comments, and the presentation of the class gift were included in this last social event shared by all prior to graduation.

As the carillon chimed, graduates filed out of Hunziker Hall (its wing not yet built) and walked to the gymnasium for commencement exercises, where family and friends were seated and waiting. By the 1960s, the number of graduates and guests exceeded the seating capacity and the program moved outdoors to this parking lot.

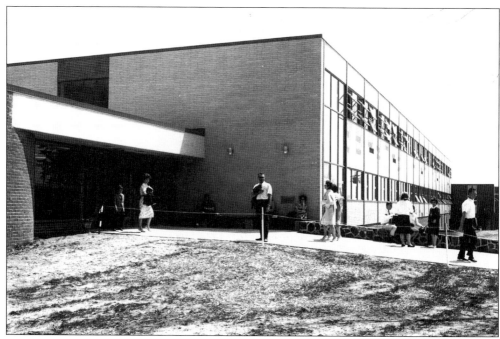

Intended to become primarily a mathematics and science wing, this Hunziker Hall addition—opened in 1961—contained a large lecture hall and a greenhouse placed on the lower level roof. At first, it also housed art classes in studio-classrooms that could easily be converted to laboratories once the art program moved to other quarters.

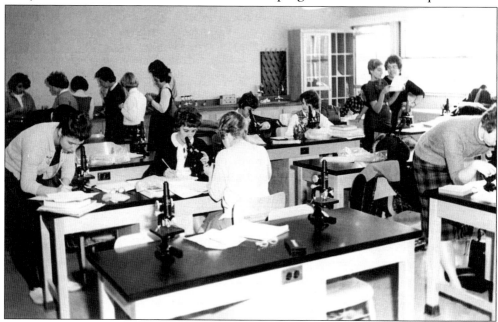

Only three degree programs, all in teacher education (K–8, K–3, grades 5–9), existed in the 1950s, but the number had grown to 13 by 1965, including five for secondary-school subjects. Before that change, science classes were much like this one, offering mostly female students only the basics in biology.

Three

GROWTH AND CHANGE

1961–1970

The 1960s were turbulent, filled with protests and demonstrations, and some of this activity rippled onto the college campus, offering a microcosm of the larger world. Far more significant, however, was the change that also marked the decade, both in U.S. society and within the college community. Indeed, there was hardly a single facet at Paterson State College (its new name as of 1958) left untouched.

New physical facilities were the most dramatic marks of change. These included construction of two residence halls, an auditorium/speech/music building, a campus school/child study center, an addition to the gymnasium, a new library, and two new classroom buildings. Also, the newly opened food service facilities in Wayne Hall in 1961 allowed remodeling of the old cafeteria in the Coach House into a college center, snack bar, and bookstore. Parking spaces now accommodated 1,500 vehicles, with an additional 200 spaces becoming available at adjoining Camp Veritans. Creation of an access road from the Hamburg Turnpike; improvements in outside lighting, paths, roads, and landscaping; and further development of the athletic field were other additions.

The curriculum, revised earlier in 1956, now underwent further changes. Until this time, every student followed a 128-credit degree program with a rigid structure of 48 credits in basic general education (12 credits each in humanities, social science, and math/science; 6 credits each in language/communication and health/physical education); 53 credits in specialization education; 15 credits in professional education; and 12 credits of electives. In the 1960s, however, a nationwide trend of loosening the curriculum structure and allowing a greater choice of so-called relevant courses impacted Paterson State College as well.

From just 3 degree programs in the 1950s for elementary teachers (general elementary, kindergarten–primary, and grades 5–9), the number had risen by the mid-1960s to 13 major programs, including 5 for secondary teachers and 5 for special K–12 fields such as art, mathematics, music, physical education, and science. In 1960, a new graduation requirement appeared: a compulsory one-week outdoor education experience at Stokes State Forest.

Changes in students, faculty, and staff also occurred. Student enrollment increased fivefold, from 531 in 1955 to 2,672 by 1966. The number of faculty and librarians grew from 35 to 212, with the percentage of those holding doctoral degrees rising from 27 to 44 percent. The number of academic departments grew from four (Communication Arts, Education, Science/Mathematics, and Social Science) to nine (Art, Education, English, Health/Physical Education, Mathematics, Music, Science, Social Science, and Speech). Full-time administrative positions also increased to meet the challenges of growth that marked this important decade.

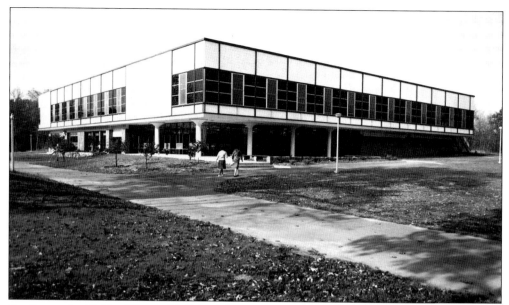

By the early 1960s, Wayne Hall had become one of the social hubs on campus. In addition to the dining facilities, it had a large student lounge and faculty lounge on the ground floor, as well as a conference room with seating for 100 people. Lack of air-conditioning at that time, however, did not allow its appeal to extend to the hot summer months.

Located on one of the highest points on the campus, Wayne Hall offered pleasant campus views and was strategically close to the planned sites for residence halls. Because of those anticipated residents, the main student dining room was built to accommodate 600 at one time, which officials in the 1950s thought would suffice for decades.

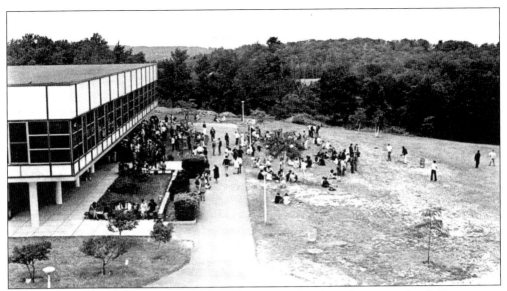

Wayne Hall stood at the edge of a vast tract of undeveloped campus land. Soon came residence halls, an athletic field complex, and the Student Center—all of them built in the background area of this photograph. Shown here is an all-college picnic, with food tables under the building overhang, clusters of picnickers, and some ballplayers.

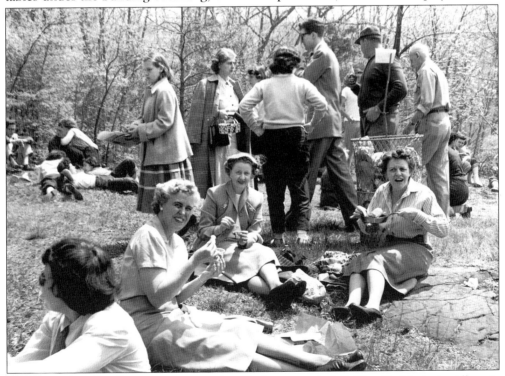

At this 1963 all-college picnic, Harriet Modemann, Ardell Elwell, Marjorie Allen (a visiting professor from England), and Prof. Alice Meeker enjoy the occasion. Alice Meeker, who spent decades inspiring thousands of students with her enthusiasm for teaching, holds a pan of warm food heated in nearby Wayne Hall.

In the summer of 1953, the college launched a children's play school called the Wee Collegians. This supervised program provided seminar students with demonstration teaching and child study, while serving as a child care opportunity for parents taking summer classes. Similar programs soon developed at most other state colleges.

By the 1960s, the Wee Collegians program had become so popular that the college divided it into two groups, calling the program for the older children the Young Scientists. Under the direction of Lawrence Ossi (right), a member of the class of 1951 and an elementary school teacher, children participated in many science enrichment activities, both indoors and outdoors.

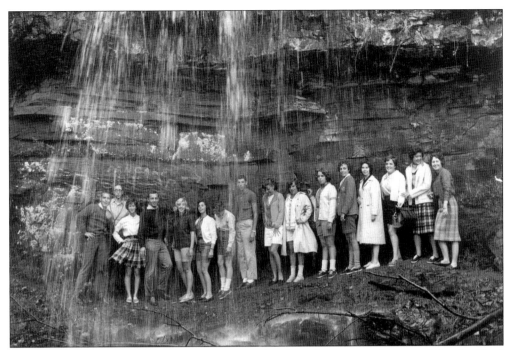

When the eastern end of the campus was undeveloped, many students and faculty liked to hike a trail to reach Buttermilk Falls, also known as Bridal Veil Falls. A straight drop of almost 50 feet into a man-made canyon (an old quarry) and still impressive after a heavy rainfall, Buttermilk Falls is more accessible since the opening of Entry 6 from Overlook Avenue.

Begun in 1939 as a camping institute at Passaic County Camp Christmas Seal, an outdoor education program evolved in the 1940s at National Camp near High Point. In the 1950s, the locale changed to Stokes State Forest, where science faculty showed how to motivate children by using the outdoors as a source of information and experience.

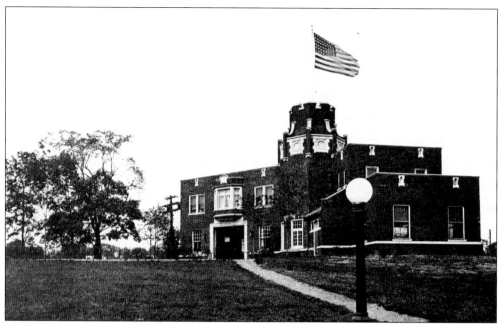

No longer called North Hall once Wayne Hall was built farther north, the Coach House was remodeled after the food service building was completed. With the old Student Union about to be demolished, this became the college center, with a snack bar and bookstore on the ground floor and offices upstairs for staff and student organizations.

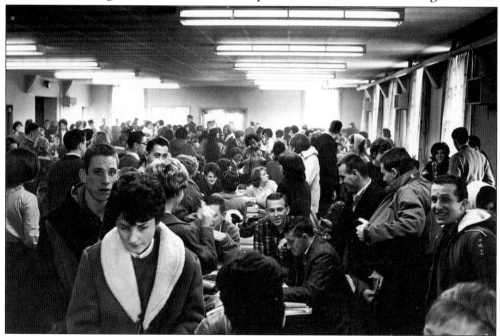

Unlike the near serenity of Wayne Hall, the snack bar was typically crowded and noisy. It was a place to eat, drink, or socialize, but definitely not a place to study. Patterns of colonization soon developed, as various groups established a regular presence at particular tables in the room.

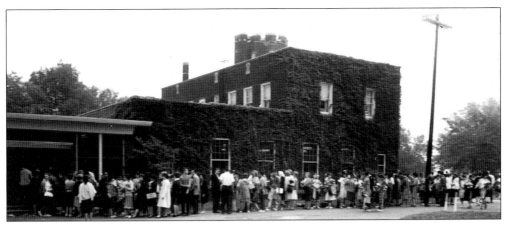

Between 1955 and 1966, full-time student enrollment climbed 400 percent, from 531 to 2,672. The two admissions officers in 1966 faced the daunting task of selecting about 700 of the best qualified from an applicant pool of nearly 3,000. The greater numbers also meant longer lines, such as this one of students waiting to buy books.

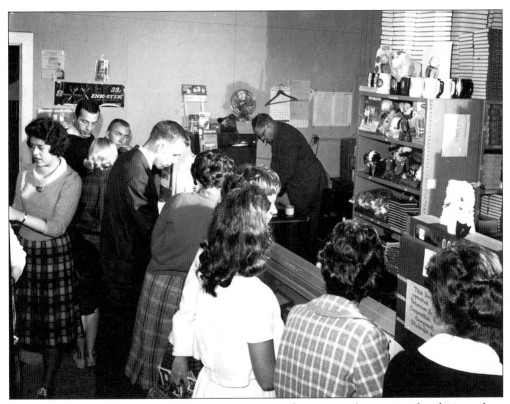

Once inside, students waited behind a counter for an employee to take their orders and retrieve the selected books from the shelves, some of which are partly seen to the right. Coffee mugs, steins, stuffed animals, notebooks, and other accessories were also available, but at this time of year, students were concerned primarily with getting their textbooks.

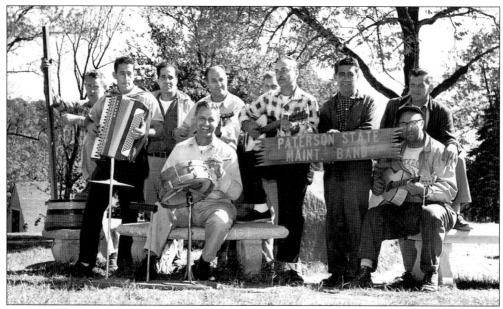

Members of the maintenance crew formed a band and used their lunch hours to hold jam sessions. Sometimes students would also join them in the lunchtime playing. The PSC Maintenance Band took its show on the road, playing in different halls for community organizations, and it even enticed Marion Shea, college president, to play piano with the group.

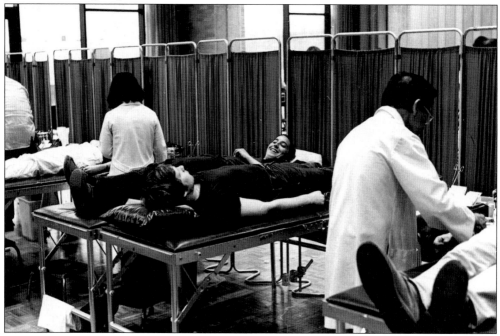

Blood drives became an annual campus event as the college community rallied behind a popular professor, Lee Hummel, whose son Rick was a hemophiliac. Such action was an echo of the 1940s, when PSTC became the first area college during World War II to organize a Red Cross college unit, which was active in a blood donor program.

When the first residence hall, Pioneer Hall, opened in 1962, it marked an important new step in the evolution of the college because it sparked a greater variety and intensity to college life, both in the daytime and at night. This picture was taken in the first week that students lived in the building, which was built to accommodate 148 female students.

Two years later, in 1964, White Hall opened, housing an additional 100 female students. With two female-only residence halls on campus, some referred to the area as "the convent on the hill," but as their former residents will quickly tell you, the mood here was anything but churchlike. To be sure, it had its quiet times but many fun times as well.

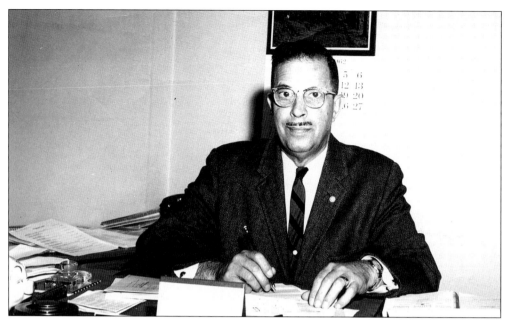

Benjamin Matelson joined the faculty in 1936 as a professor of social science and head of a new administrative unit, the Part-Time Division. As the program expanded, he became a full-time director of the renamed Evening Division, Summer Session, and Field Services. Until the 1970s, the Evening Division was independent from the daytime college and did its own scheduling and advisement.

Until his sudden death in 1967, Ben Matelson supervised the development and growth of a six-year degree program, begun in 1955, that enabled thousands of part-time students to graduate and become certified elementary school teachers. In recognition of his many contributions, college officials changed the name of Pioneer Hall to Matelson Hall.

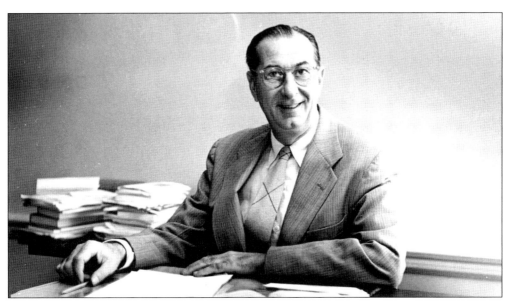

Kenneth B. White came to Paterson in 1936 as a professor of psychology and director of personnel. In 1947, he became the first dean of instruction, second only to President Shea in administrative responsibility. During his tenure he saw the faculty increase from 22 persons in the normal school to 170 by 1966, and he played a major role in upgrading both the curriculum and the quality of the faculty.

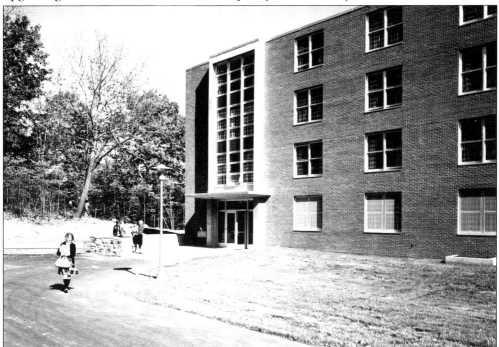

After Dr. White retired, a grateful college community changed the name of Heritage Hall to White Hall. It is quite fitting that these two men—Matelson and White—who began and ended their careers at Paterson in the same years (1936–1967) and were good friends as well as colleagues, would have side-by-side buildings named after them.

53

In 1964, passersby on Pompton Road looked beyond the students on the archery range to the new construction of the Auditorium-Music-Speech Building, as it was first known, now Shea Center for Performing Arts. As part of a $66 million voter-approved bond issue in 1959, the two residence halls, campus school, gymnasium addition, and pool were also part of this funding.

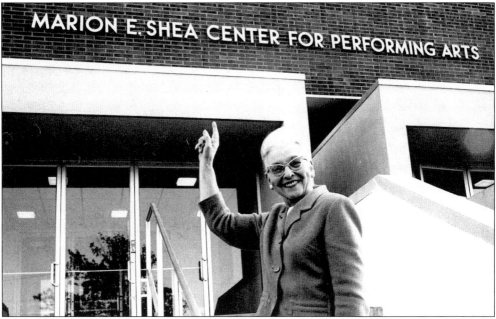

In 1963, Dr. Shea—with the support of faculty, students, and alumni—created a development fund to supplement building programs funded by the state, such as for the new auditorium building. After her retirement, an appreciative college community named the auditorium the Marion E. Shea Center for Performing Arts and invited her to its 1967 dedication.

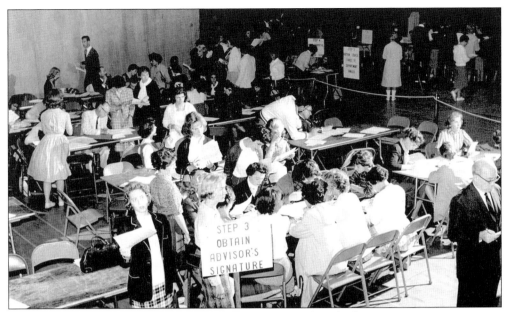

Wightman Gym also served for many years as the locale for in-person registration, which for decades was the only form of registration. Lines of students waited to get into the building and followed signs into rope-cordoned sections to get a registration card to fill out, an advisor's signature, and class admission cards to hand to instructors on the first day of class.

Faculty such as biology professor John Rosengren helped students select their classes. As course sections closed, sometimes in the midst of the selection process, smiles were far less frequent, as students scrambled to find alternate selections while faculty advisors faced the daunting challenge of finding them schedules from a dwindling list of open courses.

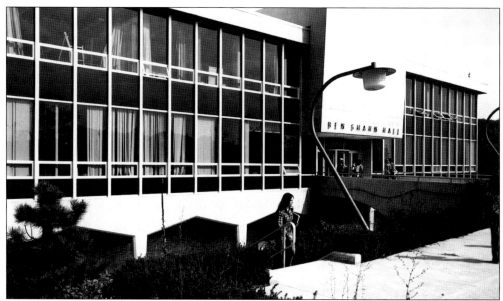

Ben Shahn Hall, named after a Lithuanian-American artist who focused on political and social themes, became home to the Art Department in 1967. Its modern architecture in a new section of campus marked a departure from the more traditional brick buildings in the older section and formed one part of a new quadrangle.

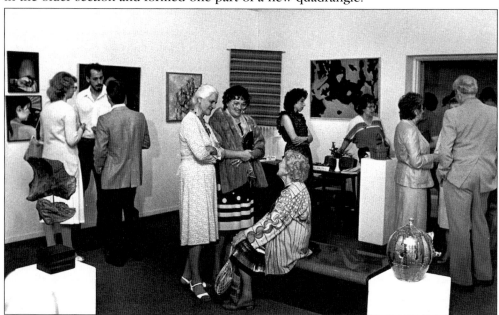

Since its establishment, the art gallery in Ben Shahn Hall has been the showplace for the work of many undergraduate and graduate art majors. Outside exhibits have been on display as well. Each exhibition opening has a reception and attracts people from inside and outside the college community. In the center of the gallery enjoying this reception are Lucille Cooke (standing left), wife of former Art Department chair Robert Cooke, and Helen Wienke Mault (standing, center), member of the class of 1959, M.A. in 1961, and former Alumni Association president.

In a scenario reminiscent of 1933–1935, the presidency remained vacant for two years. Michael B. Gilligan, president of Jersey City State College, became acting president for one year (1966–1967). Alternating his duties at the two campuses, he typically spent two days at Paterson, guiding the institution in providing necessary services while assisting faculty and administrators to plan for the future.

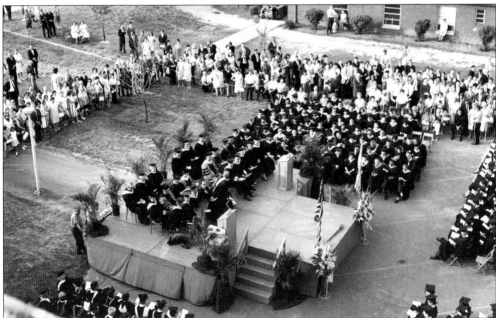

In Paterson, the college annually held a nondenominational baccalaureate service at St. Paul's Episcopal Church on the Sunday evening before commencement. On campus it was held outdoors on Sunday afternoons and later in the gymnasium. When commencement moved outdoors, as shown here in June 1967, the pre-commencement program evolved into a senior convocation.

An advertisement filmed in front of Hunziker Hall captured some of 1960s college life: cheerleaders, convertibles, and good times. However, life in the 1960s was more than that. This was a turbulent decade for America, one that began in innocence and ended with protests and violence. Some of that spilled onto campus.

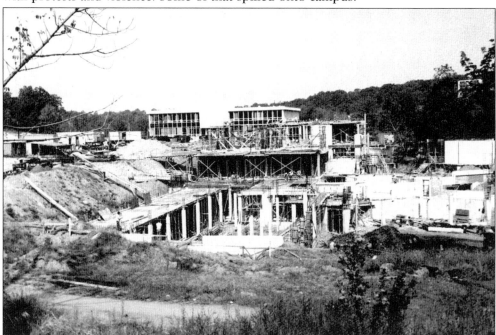

With Ben Shahn Hall in the background as the anchor, construction of another part of the new quadrangle was under way in 1967. Science Hall, its physical layout partly shaped by input from faculty and administrative focus groups, became the largest building when it opened its doors as home to all science departments and several of the social sciences.

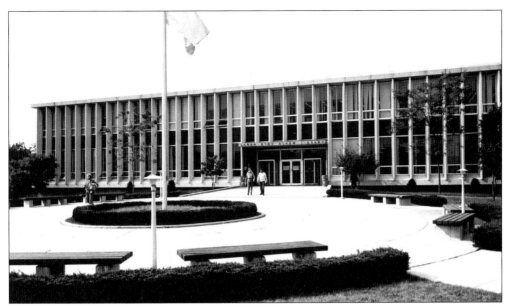

Spacious when it opened in 1956, the Sarah Byrd Askew Library was seriously overcrowded by 1965. Volumes had increased from approximately 30,000 to nearly 89,000 to meet the needs of the growing enrollment and new programs. The new library opened in 1967 and retained the name of the woman who had organized many libraries throughout the state.

Unlike in 1956, when students willingly carried 28,000 books, 6,000 pamphlets, and 250 periodicals from the second floor of Hobart Manor to Morrison Hall, professional movers hefted everything to the new library. Months before that, the library staff had reclassified the books from the Dewey decimal system to the Library of Congress system.

Although designated as a laboratory school and child study center, this building—when completed in 1965, together with a partial landfill of Gaede's Pond for parking—was used as a classroom building for two years until Raubinger Hall was built. In 1967, it began its short-lived original mission and was known as the Campus or Demonstration K–4 School, and it later became what is now Hobart Hall.

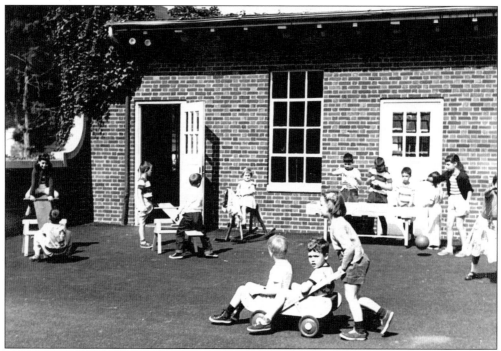

Under its only principal, Leo Hilton, the Campus School was supposed to have become a K-6 school, with either a special education or preschool class to complete its organization. An updated version of the Paterson Normal School practice schools, the Campus School closed after a few years, as new priorities to establish a multipurpose college arose.

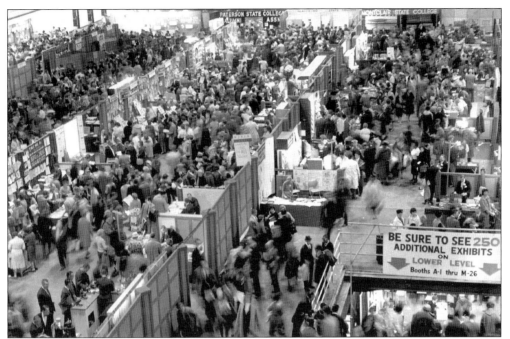

Each November, thousands of teachers descend on Atlantic City to attend the convention of the New Jersey Education Association, where they can sample a variety of programs, exhibits, and social activities. Among the many exhibits on the main floor of Convention Hall was one sponsored by the Alumni Association (see upper left-center of photograph).

The college exhibit often served as a meeting place for former classmates, as well as a place to see former teachers, such as special education professor Leola Hayes (right). Here, also, visitors signed up for the alumni reception held at a nearby hotel and received information about graduate-level opportunities available to them.

James J. Forcina was the second acting president (1967–1968) and also wore two hats. As vice president for academic affairs at then Trenton State College, he spent just two days a week at the Paterson campus. He worked closely with faculty in meeting the new state mandate to change from a teachers college to a multipurpose liberal arts institution.

Little Mary Sunshine (1967) was the first of many musicals to be performed in the new Shea Center for Performing Arts. Combining the student and faculty talents of the Music and Theatre Departments, the show was directed by Prof. Anthony Maltese, with music direction by Prof. Stanley Opalach.

After a six-year tenure as superintendent of schools in Ridgewood, Frederick M. Raubinger served as state commissioner of education from 1952 to 1966. He thus presided at the state level over many of the changes and construction at Paterson State College, and he spoke at the dedications of many of the new buildings.

Raubinger Hall, with two lecture halls and three floors of classrooms, opened in 1967 as the main classroom building. The Evening Division and Graduate Studies offices relocated to the first floor, with offices for education professors on the fourth floor, along with those of the new deans of the School of Education and School of Arts and Sciences.

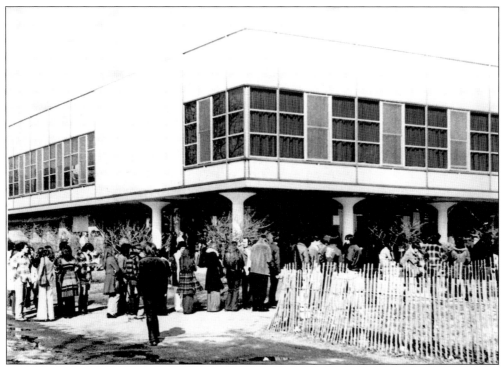

In-person registration shifted from the gymnasium to Wayne Hall, but because there was yet no other method available, long lines remained an unpleasant reality. After one cold, rainy, and windy day prompted strong criticism from the *Beacon* and the Student Government Association, the Registrar's Office adopted new procedures to reduce lengthy lines outdoors.

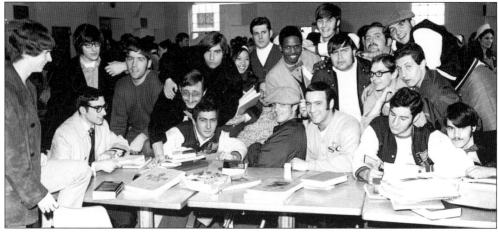

The times and students changed, but life inside the Coach House snack bar continued in similar fashion as in previous years. It remained a hangout, a place to relax and socialize with friends, to find an empty table to sit, or to go to the recognized territory of one of the organizations.

Four

TRANSFORMATION

1971–PRESENT

The 1960s could be characterized as a period of growth and change, but they were merely a prelude to the impressive evolution that followed. In that 35-year journey from yesterday to today, many things at Paterson State College changed: its name, purpose, structure, programs, size, campus, facilities, curriculum, and personnel. At the beginning of the 1970s, few could have imagined what the institution would become in this relatively short period of time.

James Karge Olsen was the first college president (1968–1972) at Paterson whose background was not in teacher education. This distinction served him in good stead, for he presided over the state-mandated institutional change from a purely teacher education emphasis to a multipurpose liberal arts college. That 1967 mandate became fully implemented under his leadership, both in curricula and administrative structure, with the establishment of associate dean positions for divisions within the School of Arts and Sciences and School of Education, and of a dean for graduate and research programs. His stewardship faced numerous challenges, ranging from issues of social unrest to contending with the state bureaucracy over larger-than-expected enrollments and limited budget allocations.

The next president, William J. McKeefery (1973–1976), pursued an aggressive goal of increased enrollment, taking the institution from about 11,700 in 1973 to about 15,000 in 1975. Before and after his presidency, William Paterson College witnessed three terms of interim presidents: Frank Zanfino, vice president of business (1972–1973 and January–August 1977) and Claude Burrill, board chairman (July 1976–January 1977). During this period the college and its programs further evolved. The Student Center was the only new building that opened in this time frame, and it quickly became the focal point of campus life because of its variety of activities.

Seymour C. Hyman brought stability to the campus with his seven-year tenure (1977–1985), after the institution had experienced five presidents or acting presidents over the previous five years. His accomplishments were significant: strengthening the quality of the academic programs, supporting faculty scholarship, implementing a master's degree in business education in 1981, creating a 60-credit general education curriculum in 1982, and establishing the Distinguished Lecturer Series, a forum for speakers with national and international prominence.

Arnold Speert had been vice president for academic affairs before assuming the presidency (1985–present). He continued to emphasize the priorities of his predecessor but also proceeded with his own vision for the institution. Under his decisive leadership, there has been a further expansion of programs, students, and physical facilities, as well as the dramatic transformation from a local college into a regional university with many prominent faculty who possess national and international reputations.

The task of leading the implementation of the college's transformation in mission and curriculum fell to James Karge Olsen (1968–1972). As the college's first out-of-state president and its first from the liberal arts, he sought an institutional name change to keep the old tradition alive yet help to create a new public image. His recommendation of William Paterson College soon won approval.

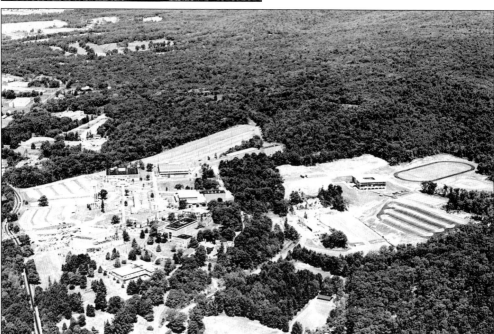

When President Olsen took office, the building spurt temporarily ceased, with most buildings clustered in the western end and only the power plant, athletic fields, and art building to the east. During his administration substantial programmatic changes occurred, as well as the creation of academic divisions and associate dean positions.

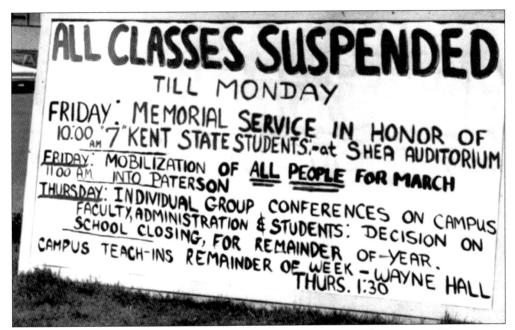

On May 4, 1970, a student demonstration at Kent State against the Vietnam War came to a tragic end when a contingent of 28 Ohio National Guardsmen opened fire, killing four students, permanently paralyzing another, and wounding eight others. Paterson was one of hundreds of colleges to suspend classes and hold a memorial service and teach-ins.

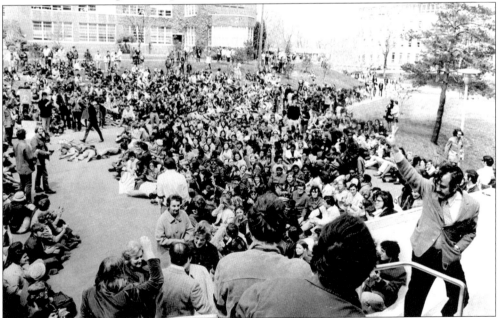

Stan Kyriakides (lower right), Lee Hummel, and Anita Este (lower center), assistant director of Student Personnel Services, enter Shea Auditorium for a memorial service after passing among students gathered outside who were unable to enter but wanted somehow to share in the moment. At left center, students simulate those killed at Kent State.

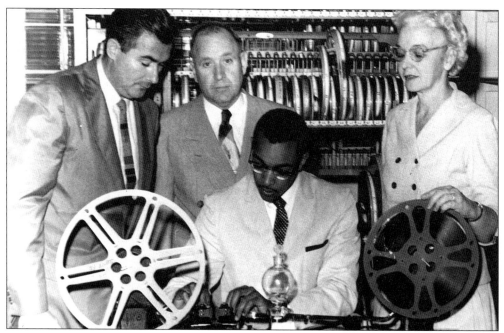

From 1957 to 1973, Paterson State became the repository for the Passaic County Film Library. Ernest Siegel (left), audiovisual coordinator; Harold J. Straub, county superintendent of schools; and Marion Shea, college president, stand by Dennis Seale (seated), who later became director of admissions but at that time handled the distributions to public schools in the county.

Midday Artists concert series in Shea Auditorium drew large audiences throughout the 1970s. These performances took many forms—a trio, a quartet, a chamber orchestra, vocal and instrumental soloists—sometimes performed by guest artists but mostly by music majors, occasionally including music faculty and some of their original works.

Frank J. Zanfino, a member of the class of 1949, began his administrative career as business manager, and as the college expanded, so too did his responsibilities, leading to his appointment as vice president of administration and finance. In 1972–1973 and again in 1977, he served as acting president. His leadership skills and familiarity with the college provided the necessary continuity during presidential searches. Zanfino Plaza, on the western side of the Machuga Student Center, is named in his honor.

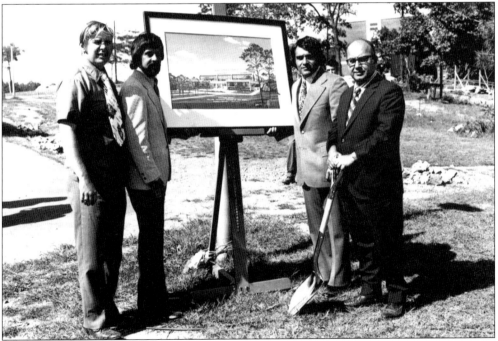

The groundbreaking ceremony for construction of the Student Center was a particularly satisfying moment in Frank Zanfino's first interim term as acting president. With Zanfino are, from left to right, Robert Johnson, director of facilities; Anthony Barone, director of student activities; and Dominic Baccollo, dean of students. The building opened in 1974.

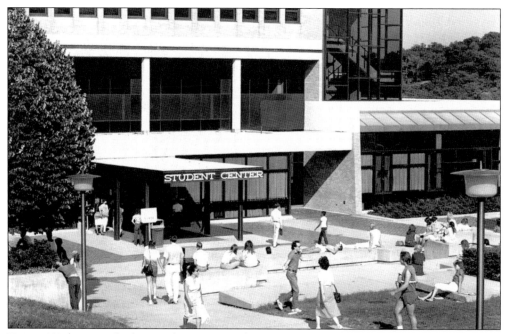

From 1974 onward, the Student Center became the focal point of student activities, both inside and outside, at what was later named Zanfino Plaza. The indoor facilities included a cafeteria, a dining room, Billy Pat's Pub, a bookstore, a game room, a gallery lounge, a ballroom, meeting rooms, and offices for the *Beacon*, the Student Government Association, and other student organizations.

Once the Student Center opened, the Coach House saw new duty for a short period, as it became another venue for theatrical productions. This was an ambitious time for the Theatre Department, including having artists-in-residence such as Alfred Drake and Kim Hunter teaching acting classes and performing in full productions with students.

President William J. McKeefery (1973–1976) continually strove to expand the college into a regional institution. Enrollments grew from more than 11,000 in 1973 to about 15,000 in 1976, but limited state funding and lack of space obliged his successors to reduce the numbers, first by nearly 3,000 in the late 1970s, and by another 2,000 in the early 1980s. From 1985 to 1999, total enrollment remained in the 9,200 to 9,800 range.

Under a separate administrative structure, Evening Division classes, such as this one taught by Prof. Louis Gaydosh, contributed substantially to total college enrollment. In fall 1974, for example, there were 7,900 Day Division students and more than 6,000 Evening Division students, with the latter equally divided between undergraduates and graduates.

71

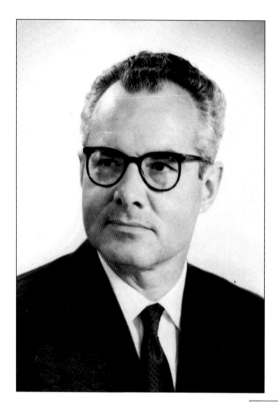

Claude Burrill was a member of the William Paterson College Board of Trustees who became acting president (July 1976–January 1977) after Dr. McKeefery's sudden resignation. His was essentially a caretaker administration, seeing to it that operations ran smoothly while the board launched a search for a new president.

As always, emphasis remained on providing the best possible learning environment in terms of class size, curricula, facilities, and faculty. In the 1970s, freshman hazing came to an end and degree programs became more structured in general education requirements, even as liberal studies majors grew in popularity.

Seymour C. Hyman brought stability to the college with his seven-year presidency (1977–1985) after five presidents or acting presidents in the preceding five years. Among his numerous accomplishments were creating positive student/faculty/space ratios and placing a strong emphasis on academic quality, as reflected in curriculum reform, new personnel, and support for faculty scholarship. His presidency was noted for his pursuit of a vision for the institution that allowed for faculty and staff input.

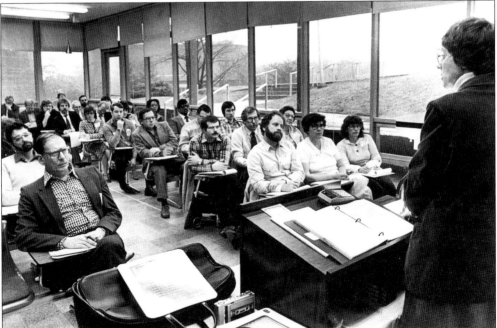

The college had offered extension courses at off-campus centers since the 1960s, but they were only education courses for teachers. A new direction in community outreach took place with the advent of on-campus continuing education programs, such as this 1982 class, that were for educators but served other groups as well.

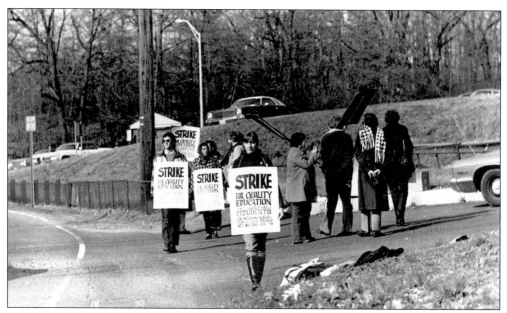

On Monday, September 29, 1980, students staged a strike in protest of the rising cost of education and the reduction of financial aid. Students at all six New Jersey state colleges united, joining forces with the American Federation of Teachers, and on the same day demonstrated their disapproval in a flashback to student protests of an earlier decade.

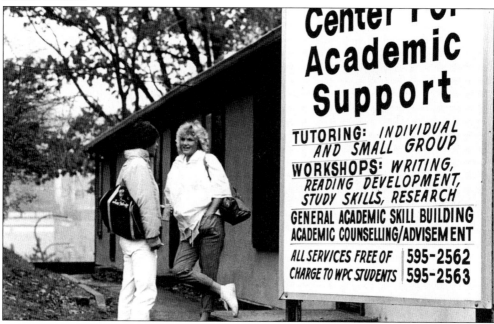

The last remaining barracks building, the one near the Coach House that had been the snack bar overflow in the 1950s, took on a new purpose in its conversion to the Center for Academic Support. The Center for Academic Support is now in Hunziker Wing, and the separate Gloria S. Williams Advisement Center in Wayne Hall handles that aspect of academic counseling.

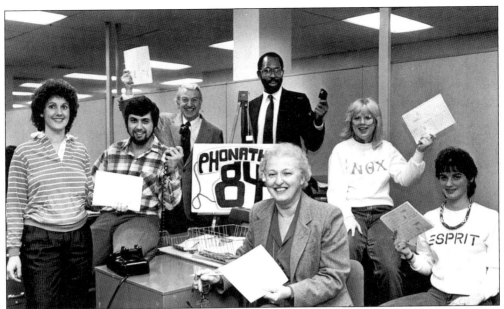

Annual campus phonathons to college alumni became a means of raising scholarship funds through friendly competition among various clubs and organizations. The 1984 effort, aided by Prof. Anthony Maltese (third from left), director of housing Gary Hutton (fourth from left), and Gilda Walsh (center, seated), enabled the Alumni Association to expand its scholarship program by 44 percent.

Basketball games moved from the tight quarters in the gym to the Rec Center's large multipurpose area, which also accommodated 4,000 spectators for concerts or exhibitions. With volleyball and handball and racquetball courts, a room with dance barre and mirrors, a weight-exercise room, saunas, and a whirlpool, it became the center of physical activities.

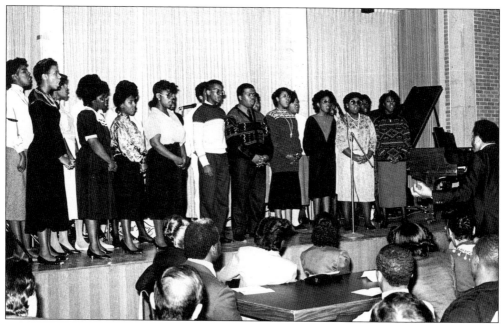

The gospel choir has delighted listeners for many years with its excellent sound and infectious music. Student participants sign up, receive college credit, and perform in many different venues both on and off campus. Theirs is truly an ecumenical effort, for they sing in many churches of all denominations.

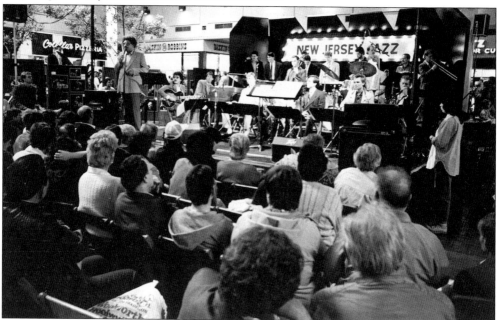

Prof. Martin Krivin—with input from legendary jazz trumpeter Thad Jones, the first of many in-residence artist-teachers—founded the jazz studies program in 1973. Student jazz ensembles perform Sunday concerts in the Jazz Room on campus, as well as off-campus, such as here at Willowbrook Mall, where Rufus Reid (left), former director of the jazz studies program, welcomes the audience.

After serving as vice president for academic affairs, Arnold Speert succeeded Dr. Hyman in 1985 as president. While he continued many of his predecessor's policies and priorities, he also began to realize his own vision for the college. He brought in a team of administrative experts to assist him in advancing the institution both academically and financially. He acquired land and buildings, constructed new facilities, prompted a structural reorganization of the college and a comprehensive program review, obtained large donations, and led the institution in becoming a diverse, comprehensive regional university, with a status befitting its enhanced reputation in the field of higher education.

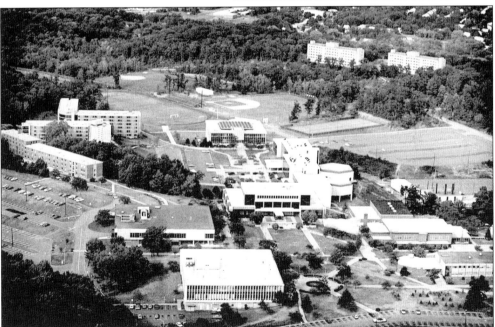

In 1985, the campus view included—in addition to buildings mentioned in earlier pages—the Towers (left), a four-winged residence hall with rooms and suites to accommodate 1,033 students; Heritage Hall and Pioneer Hall (upper right), apartment-style residences for 530 students; expanded athletic fields; and additional parking facilities.

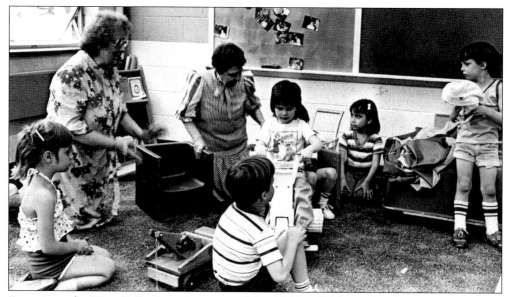

Ever since the Wee Collegians program of the 1950s, child care has been an important element of campus activities, as shown in this 1970s photograph with Profs. Ruth Fern and Ruth Klein. The state-licensed Child Development Center, located in Hunziker Wing 35, provides an affordable and balanced preschool program for children ages two-and-a-half to six. The center serves children and grandchildren of students, faculty, staff, and alumni.

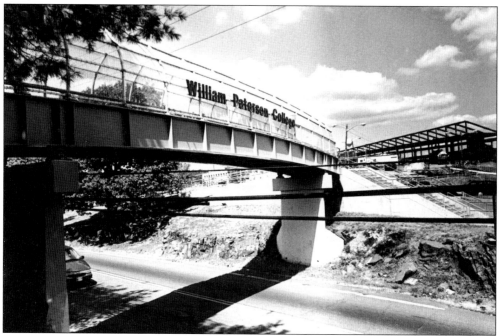

The new barrier-free footbridge over Pompton Road provided an ideal location to promote name recognition to those in vehicular traffic below as part of a larger effort to enhance the institution's public image. Also visible in this September 1995 photograph is the steel-beam frame structure of the Atrium nearing completion.

At the Student Center, one often finds tables set up outdoors on the main or lower levels. Seeking to attract students may be vendors, clubs, nonprofit or charitable organizations—some selling their wares, others their services, and still others seeking petition signers or registrants. You never know from one day to the next what you will find.

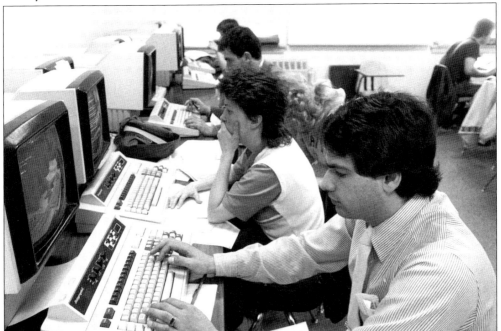

With the dawning of the personal computer age, William Paterson College was at the forefront among colleges in creating computer labs for students to learn and use the new technology. First set up in the Coach House, such labs were eventually located in most campus buildings. Note the size of the keyboards compared to those of today.

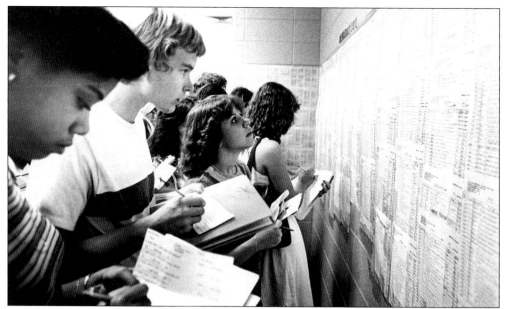

Before online book buying, alternate stores, and self-selection in the college bookstore, large computer-generated lists of books for courses were posted on walls at the beginning of each semester. Students faced the task of finding what books to buy and then waiting in the ever-present lines to ask a clerk to pull them from the shelves for purchase.

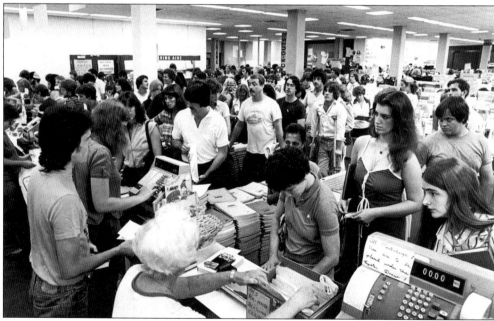

The first week of the semester in the bookstore, despite the multiple cashiers and clerks, is always an experience, with long lines and a test of patience, not to mention the dent in one's wallet when learning the total cost. The store's buyback policy and the availability of used books help somewhat, but few students cherish this part of college life.

The tradition of holding classes outdoors in pleasant weather, begun in the 1950s as depicted earlier in this book, has continued ever since but now throughout a wider expanse of campus grounds. In this photograph taken near Wightman Gym with Wayne Hall in the background, Prof. Dan Skillen conducts his group dynamics class.

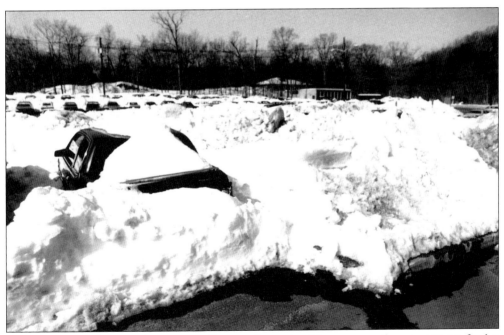

As many a resident student can tell you, the only thing worse than trying to find a parking space happens in winter when you have to devise a way to unpark your car after it's been plowed in. This is especially true the day after the storm, when the plowed snow has hardened. This 1994 photograph was taken in Parking Lot 5, also known as "the airstrip."

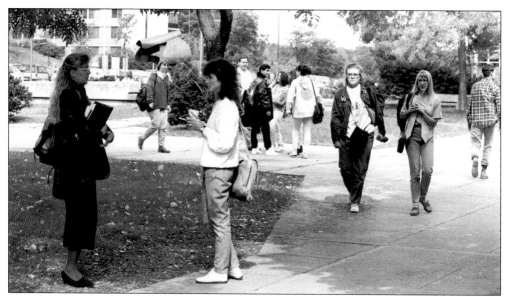

Walking across campus from one place to another provides all members of the university community with the strong likelihood of chance encounters with acquaintances, friends, or colleagues. The frequency of these accidental meetings and subsequent conversations is so commonplace that they actually comprise an integral part of the social life on campus.

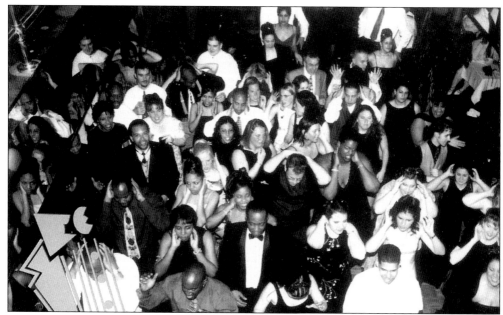

For the 1999 Senior Dinner Dance, more than 300 partygoers boarded the *Princess*, a large yacht, for a four-hour cruise against the panorama of the New York City skyline. This version of the popular annual event included an elegant dinner buffet, music, dancing, mingling on the two floors, and enjoying the night scenery on deck.

Five

ACADEMICS

When founded in 1855 as Paterson City Normal School, the institution's goal was to provide yearlong in-service training for local teachers. Classes were held only on Wednesday evenings and Saturday mornings in School No. 1 in the city center. Over the years, the institution evolved into a comprehensive regional university serving nearly 11,500 students who can take classes seven days a week on a vast multiple-site, 370-acre campus or at satellite centers in Morris and Sussex Counties.

In the 1950s, the institution's focus remained exclusively on teacher education, once the preclinical nursing (1943–1951) and business education (1943–1957) programs were terminated. The three education degree programs (general elementary, kindergarten–primary, grades 5–9) had grown to 13 by 1965, with the addition of five secondary school and five special fields curricula. Today, the university offers 30 undergraduate and 19 graduate degree programs, plus numerous certification programs. Business and nursing are important degree program offerings, as are many others in the arts, communication, humanities, sciences, and social sciences. Myriad continuing education and community outreach opportunities also are available.

The institution has achieved significant milestones in recent years in recognition of its commitment to academic excellence, including attainment of university status in 1997 and reaccreditation by the Middle States Commission on Higher Education in 2001. Although the scope of its offerings increased dramatically, the essence of the institution remains constant: developing creative opportunities for learning, with an emphasis on student success.

This tradition of promoting individual student success is rooted in a faculty whose first priority is teaching and in small class sizes that encourage one-on-one interactions, allowing students to benefit from the wealth of scholarship and real-world experience their professors bring to the classroom. In 1963, Kenneth White, dean of the college, took pride in the fact that 44 percent of faculty held doctoral degrees, up from 26 percent in 1953. Today, 90 percent of full-time faculty members hold a Ph.D. or the highest degree in their area of expertise. In every academic field, professors of national and international stature serve as mentors to their students and provide extra depth to their courses, while honors programs offer unique interdisciplinary approaches to rigorous, in-depth study in selected majors.

Since the early 1890s when normal school students practiced their profession in a model school, the institution has provided educational opportunities that combine classroom learning with real world experience. Today, students work alongside their professors, conducting high-level research. Internships and field experiences give students a competitive edge after graduation, and capstone projects provide new insights into chosen fields, enhance research skills, and provide practical perspectives on career choices.

The university also has been at the forefront in incorporating technology into the curriculum, from its first computer lab set up in the Coach House during the 1980s to its current capabilities, which include everything from Web-based courses and instructional television to interactive classrooms and other state-of-the-art learning resources.

WILLIAM PATERSON UNIVERSITY

Distinguished Scholars
Dedicated Teachers

William Paterson's Fulbright Scholars exemplify a tradition of academic excellence and commitment to student success.

William Paterson offers

- nationally renowned undergraduate and graduate programs
- access to state-of-the-art information and communications technology
- low student to faculty ratio
- small class size
- flexible scheduling—evenings and weekends
- student research and honors programs
- national and international student exchanges, internships, and leadership opportunities
- scholarships and financial assistance packages

From left to right, top to bottom: Vincent Parrillo, Sociology; Sara Nalle, History; Donna Perry, English; William Small, Political Science; Martin Laurence, Economics (recipient of two awards); George Robb, History; Ching-Yeh Hu, Biology (recipient of two awards); Jonathan Bone, History; Melvin Edelstein, History; Vernon McClean, African, African American and Caribbean Studies; Theodore Cook, History; Isabel Tirado, History; Carol Gruber, History; Reynold Weidenaar, Communication; Bruce Williams, Languages and Cultures; Leslie Agard-Jones, African, African American and Caribbean Studies; Martin Weinstein, Political Science; John Livingston, History; Michael Principe, Political Science; Krista O'Donnell, History; David Lelyveld, History; Lois Wolf, Political Science; Joanne Cho, History; Catarina Feldmann, English; Charlotte Nekola, English; Geoffrey Pope, Anthropology; John Mason, Political Science

WILLIAM PATERSON UNIVERSITY
1855
WAYNE, NEW JERSEY 07470
1.877.WPU.EXCEL • WWW.WPUNJ.EDU

A university's strength rests in large measure on the academic quality of its faculty. William Paterson University's faculty has won 29 Fulbright Awards. This U.S. government flagship program in international educational exchange each year sends scholars to more than 140 countries to lecture or conduct research in their discipline.

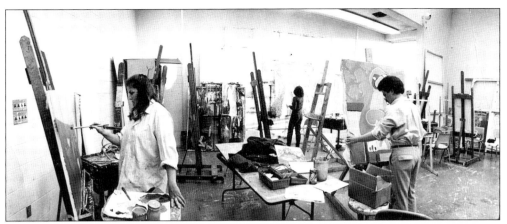

B.F.A. and M.F.A. programs with concentrations in ceramics, computer art, painting, photography, printmaking, sculpture, textiles, graphics, or furniture design, as well as B.A. programs in art history and studio art, offer abundant choices. Painting, one of the oldest specialties, remains popular in the spacious Power Art Center studio.

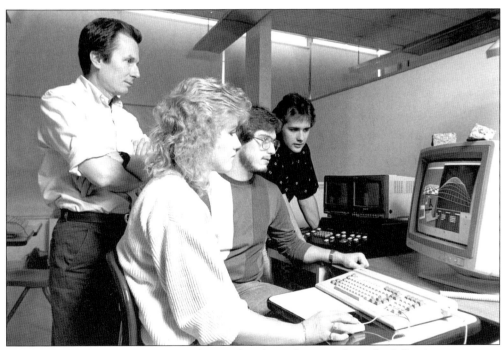

Prof. David Haxton helps students develop their technical skills in computer animation. In this aspect of the applied arts, students learn the use of graphics software to paint 3-D computer graphics in the application of modeling to art and design, and the principles, concepts, and processes of computer animation to generate animated sequences.

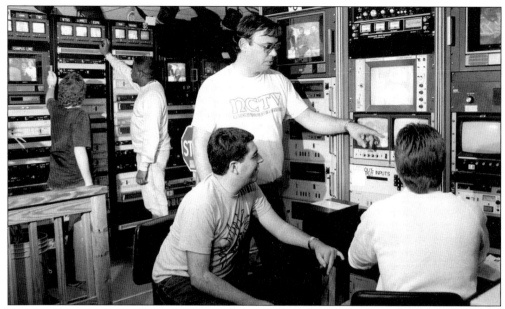

The B.A. program in communication offers concentrations in film, theater, journalism, interpersonal communication, radio, and television. In the latter, courses in production provide experience in electronic and digital media through opportunities to work in studio and production facilities. There is also an M.A. in communication and media studies.

Some of the technology has changed since the 1980s, when Prof. Leandro Katz supervised this group of students in filmmaking techniques. Still, the learning-by-doing subject matter is similar, from preproduction organization through production techniques, from sync sound filmmaking and dramatic lighting to postproduction editing work.

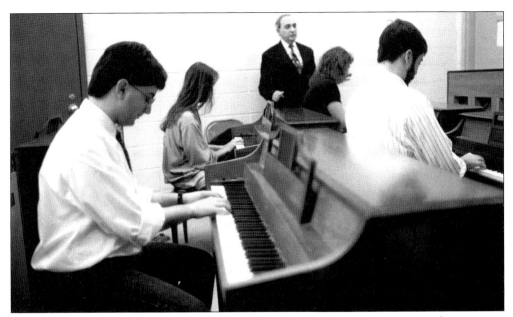

Offering undergraduate and graduate degree programs in jazz studies, music education, and music management, the Music Department also has undergraduate programs in sound engineering arts and music studies. Functional piano classes in the piano lab, such as this one with Prof. Donaldo Garcia, guide students in mastering styles and techniques.

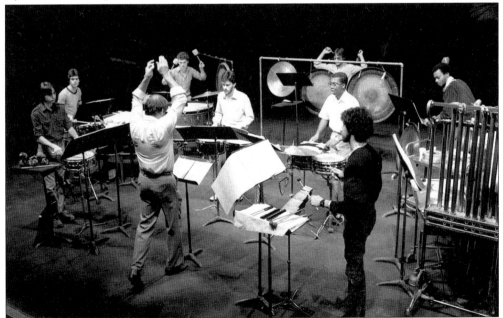

In a 1980s rehearsal, Prof. Raymond DesRoches prepares the New Jersey Percussion Ensemble for an upcoming concert. The Midday Artists Series, Jazz Room Series, New Music Festival Series, and the High Mountain Symphony at William Paterson provide rich and varied musical performances on an ongoing basis for students and the community at large.

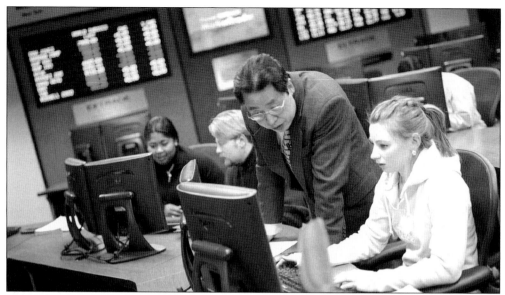

The E*TRADE Financial Learning Center, a gift from Christos M. Cotsakos, a member of the class of 1973 and E*TRADE, provides students in the Cotsakos College of Business, guided here by Prof. Haiyang Chen, with a real-time simulated trading and financial center to learn the principles of investing and money management and to replicate real-world situations, including designing trading and risk management strategies, and back-office functions such as trade posting, settlement, accounting, and compliance.

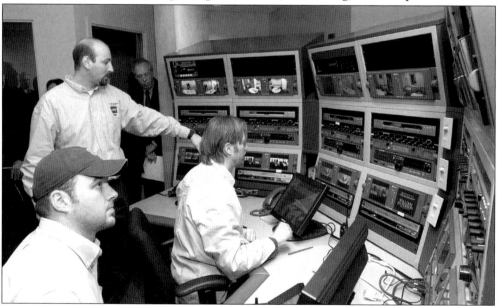

The Russ Berrie Professional Sales Laboratory, a facility in the Russ Berrie Institute for Professional Sales, helps students and working professionals master communication skills with state-of-the-art technology, such as robotic digital cameras to record practice sales presentations, single or split screens to display the interactions, one-way mirrors to allow viewing by professors, and an editing room for creating electronic DVD portfolios.

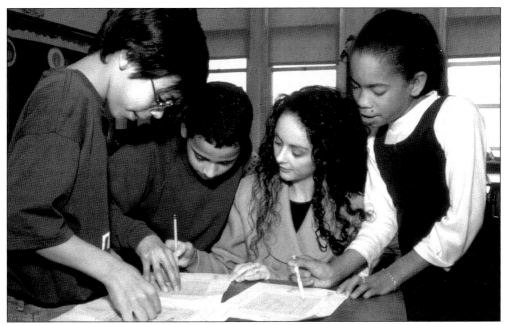

Student teaching is the oldest hands-on experience in the university's history, harking back to normal school years. After a practicum semester of courses on curriculum and pedagogy, together with observing an experienced classroom teacher two days a week, education students then learn by doing, taking charge of a class under supervision.

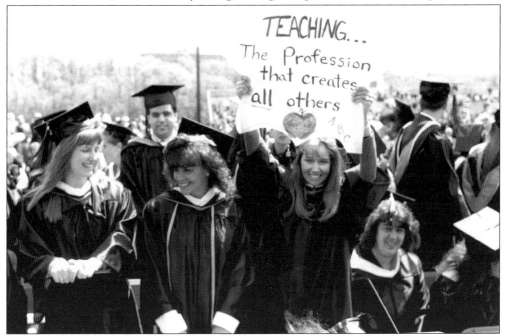

Taught by dozens of teachers throughout their lives, education graduates begin their own careers teaching others. In doing so, they will likely model themselves after the teachers who most influenced them. They also utilize knowledge and techniques acquired at William Paterson, continuing the legacy begun in normal school years.

The Cognitive Science Lab utilizes computer modeling and simulations for perceptual testing communicating to the brain hemispheres, as well as spatial memory testing. Other areas of research include physiological monitoring and stimulus display, dream studies research, and interfacing music with cognitive structures of the mind/brain.

By integrating an innovative, multimedia Intranet/Internet-based learning and teaching environment into the curriculum, the Multimedia Language Center supports and enhances instructional delivery of foreign language courses. This technology aids the development and practice of language, research, and communication skills in the foreign language.

The Speech and Hearing Clinic is a regional resource for a full range of diagnostic and therapeutic services, preparing its graduates to interact successfully with clients and other professionals in a variety of employment settings. For more than 40 years, it has provided quality professional services to campus personnel and surrounding communities.

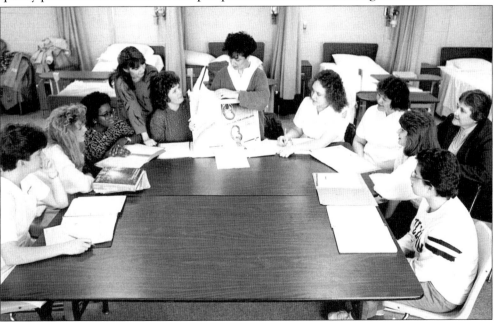

From 1944 to 1951, nursing school students at Paterson and Passaic hospitals spent one semester at PSTC. Since the 1970s, a B.S.N. program has given students a strong foundation in nursing and clinical experience, guided here by Prof. Helen Maciorowski (far right). In recent years an M.S.N. program has allowed students to function as advanced clinical practice nurses, educators, or administrators.

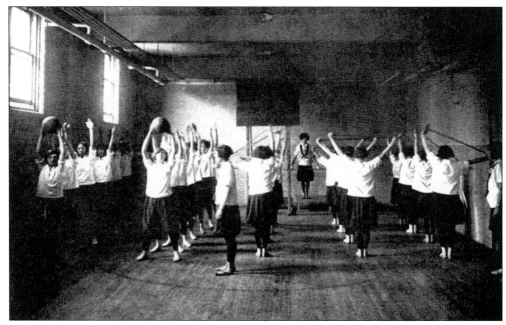

Women's physical education classes (*c.* 1925) were held in the basement of School No. 24. All students were required to wear the same modest uniform of "black bloomers, black stockings, white middy, sneakers, and no tie." The class then was known as physical training, and the exercises were conducted with decorum in a ladylike manner.

Today, the Department of Exercise and Movement Sciences offers a B.S. degree program with concentrations in athletic training education, exercise physiology, and K–12 teacher certification. Credit and noncredit classes in aerobics utilize various exercise regimens that are more energetic than generations ago and with much different attire than was worn back then.

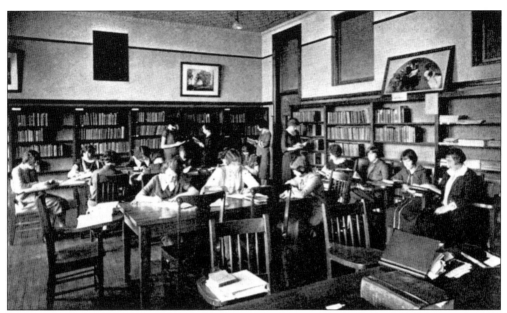

In this earliest known library photograph from the first Paterson State Normal School catalog (1925–1926), the female students all appear quite studious. In its first of five locations, the library began in the spring of 1924 with a collection of 1,500 books. By 1934, the library contained 11,000 volumes and 8,000 mounted illustrations for practice teaching.

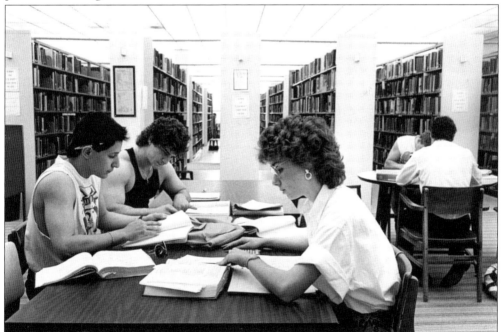

A major renovation and expansion of the library was completed in 1995. Today, the David and Lorraine Cheng Library contains numerous places for research: tables near open stacks, carrels, reading and listening and video rooms, study and conference rooms, the electronic reference lab, and the curriculum materials room.

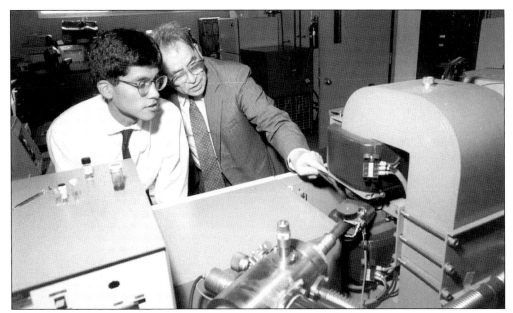

Advanced science students learn to use modern analytical instrumentation, such as the mass spectrometer that Prof. Gurdial Sharma (right) is showing here. Other lab instrumentation includes a nuclear magnetic resonance spectrometer, a Fourier transform spectrophotometer, a plasma spectrometer, and an atomic absorption spectrometer.

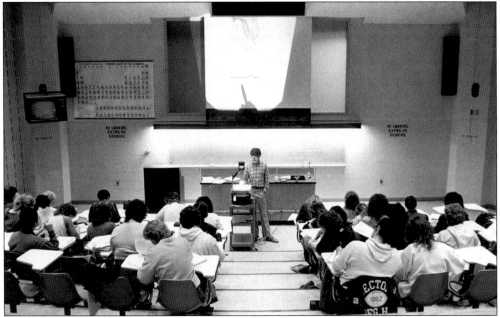

Some science classes meet in combined sections for a lecture presentation in one of the two amphitheater-style lecture halls, then split into separate units for the lab portion of the course. The Departments of Biology, Chemistry and Physics, and Environmental Science and Geography offer a wide array of introductory and advanced lab courses.

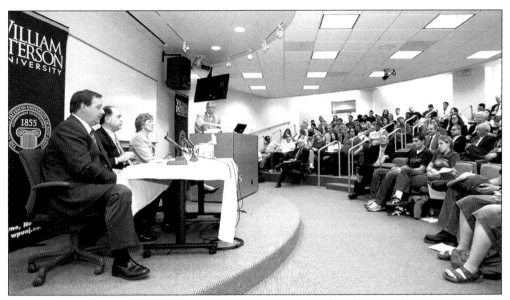

Business Leadership Forum programs supplement regular classes. This one, in March 2003 on corporate culture and ethics, included three leading business executives, all university alumni: Raymond Arthur, a member of the class of 1982, chief financial officer of Toys "R" Us; William Pesce, a member of the class of 1973, president and CEO of John Wiley and Sons; and Eileen Scott, a member of the class of 1976, CEO of Pathmark Stores.

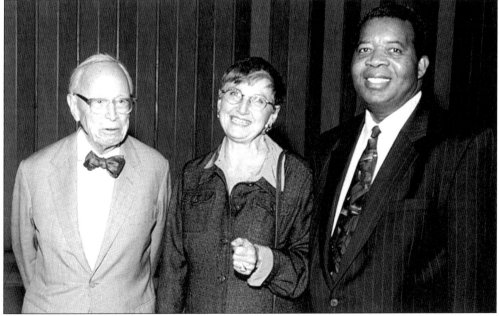

Continuing a tradition begun in the 1950s of inviting distinguished speakers to the campus, the University Lecture Series launched its inaugural program on November 19, 1999, with Arthur Schlesinger Jr., Pulitzer Prize–winning historian. With Schlesinger are Carol Gruber, professor emeritus of history, and Chernoh Sesay, provost and executive vice president.

Special short-term field study abroad courses have been a university staple since the 1960s. On this 2002 trip to study the cultures of central Europe, students visited universities in Prague, Olomouc, and Krakow. They also stopped at this chapel ossuary in Kutna Hora, Czech Republic. A longer form of travel and study is the semester abroad program, with individual opportunities to take transfer credit classes at universities throughout the world and immerse oneself into the host country's culture.

Among the many international study opportunities available to William Paterson students is the four-week summer program at St. Edmund's College, which is part of England's Cambridge University. Students take two comparative courses, hearing lectures from faculty from both institutions, and do field study work in London.

Six

ATHLETICS

In his 1872 report outlining the curriculum for Paterson City Normal School, Samuel E. Hosford, superintendent of schools, stated that "no provision was made for physical education." Printed 1912 permanent record cards still showed no listing of physical education among available courses, but the subject does appear in the 1922 city normal school catalog. Once the school became a state institution in 1923, an interest in athletics—apart from physical education classes—evolved.

Creation of a men's basketball team in the early 1920s—followed quickly by others in soccer, tennis, baseball, swimming, and fencing—resulted in formation of a Men's Athletic Association in 1926. Other intercollegiate sports—including bowling, cross-country, and golf—later emerged. Women's intramural basketball and tennis teams also evolved in the 1920s. In the early 1940s, a Women's Sports Club, renamed the Women's Athletic Association (WAA) in 1948, developed an extensive intramural sports program, including badminton, bowling, roller-skating, softball, and swimming. In 1958, the WAA became the Women's Recreation Association and existed until men's and women's sports merged in the 1970s, ending the separate male/female athletic associations.

In the past half-century, various teams have achieved impressive heights. For example, between the 1950s and the 1980s, the fencing team won seven national championships and seven state titles under coach Ray Miller. From 1970 to 1987, the women's tennis team under coach Virginia Overdorf (National Coach of the Year in 1984) never had a losing season and was nationally ranked in the top 10 for several years.

The baseball team won its first New Jersey State Conference title in 1959 and competed in the National Association of Intercollegiate Athletics postseason tournament in Alpine, Texas. Recently, under veteran coach Jeff Albies (a member of the American Baseball Coaches Association Hall of Fame), the team won 2 national championships (1992, 1996), 11 New Jersey Athletic Conference (NJAC) crowns, 7 National Collegiate Athletic Association (NCAA) regional titles, and a 1999 third-place national finish.

The men's basketball team claimed three consecutive NJAC titles (2000–2002), and played in the 1999 and 2001 Division III Final Fours, including the 2001 national championship game. Meanwhile, the women's team reached the NCAA Division III tournament numerous times, winning the NJAC championship in 1993. The softball team captured two NJAC titles (1999, 2003), and in 2001 hosted and won the NCAA East Regional championship and played in the NCAA Division III Softball Championship for the first time. The field hockey team reached the NCAA tournament in 2001. University athletes also have earned individual national titles in track and field and swimming.

Today, 18 men's and women's teams compete in NCAA Division III and NJAC intercollegiate sports. In addition to intercollegiate athletics, the university offers many opportunities for students who enjoy sports, including recreational programs and physical fitness activities, which, as noted in the 1925–1926 student handbook, provide results that "may be seen in strength, health, poise, and vim."

This baseball team with coach Jeff Albies (standing left) and assistant coach Bobby Lauterhahn (far right) achieved a major milestone in 1992, when it became the Division III National Champion. In 1996, the team won the national championship again, capping a 39-win season. In all, coach Albies's teams have made 7 College World Series appearances and received 18 NCAA playoff invitations.

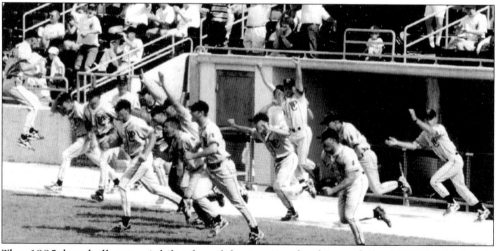

The 1995 baseball team jubilantly celebrates its clinching of the 1995 Mid-Atlantic Regional title. Under coach Albies, who has more than 800 wins since coming to William Paterson in 1975, the baseball team has notched 11 NJAC crowns and 2 other Mid-Atlantic Regional Championships, in 1992 and 1996.

Since coach Erin Monahan's arrival in 1992, the women's basketball teams have posted more than 200 wins and a high total winning percentage. A former standout player herself on William Paterson teams, Monahan led the 1990 Pioneers to an Eastern Collegiate Athletic Conference (ECAC) title. The teams she has coached have earned four invitations to the NCAA Division III tournament, twice reaching the Elite Eight, in 1995 and 1998, and a berth in the Sweet 16 in 1997. In 1993, the Pioneers achieved the first NJAC championship in the university's history.

Men's basketball has garnered many titles since normal school years. The teams of coach John Adams (1974–1986) compiled a 222-87 record, including 4 NJAC titles and 2 NCAA South Atlantic championships. Teams under coach Jose Rebimbas (since 1995) amassed nearly 200 wins and 3 consecutive conference championships (2000–2002) and reached the NCAA Final Four in 1999 and 2001.

Of all the standouts on men's and women's cross-country teams, Tom Fleming, a member of the class of 1973, is among the best. Named New Jersey College Athlete of the Year in 1972 by the Sportswriters Association, he won the New York City Marathon in 1973 and 1975, and placed second in the Boston Marathon (1973, 1974) and third in 1976. Shown here leading the pack in the 1981 Los Angeles Marathon, he ranked as one of the top four U.S. runners throughout most of the 1970s.

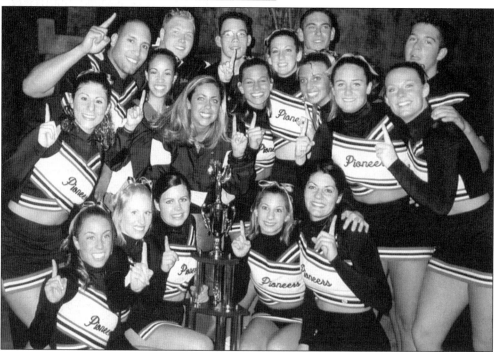

The Pioneers, long considered among the best cheerleaders in Division III, won the 2002 national championship held in Orlando, Florida. Their outstanding achievement follows in the rich tradition set by their predecessors, who won championships in the Metropolitan Intercollegiate Cheering Competitions in 1961, 1962, 1963, 1965, and 1966.

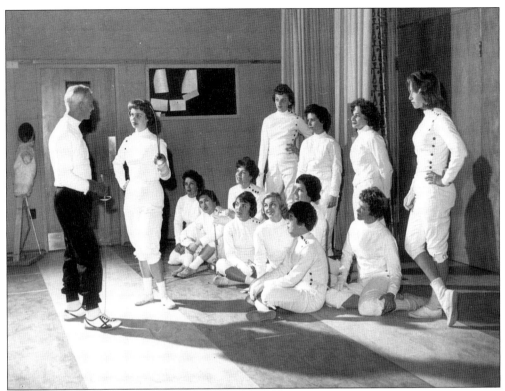

Under coach Ray Miller, shown here with his 1961 fencing team, the Pioneers were national champions seven times (1956, 1958, 1959, 1961, 1962, 1964, and 1966) and state champions seven times (1974, 1975, 1976, 1977, 1981, 1982, and 1983). Prof. Alphonse Sully became the men's fencing coach in 1962 and led his team to many impressive seasons.

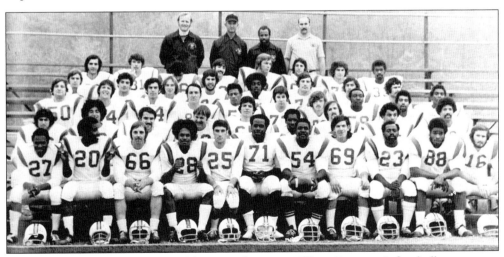

In the competitive New Jersey Athletic Conference, William Paterson's football teams over the years have included outstanding players whose records remain unbroken. Football on campus began as an intramural sport and eventually evolved into varsity competition. Above is the 1977 team with coach Art Eason (back row, second from right).

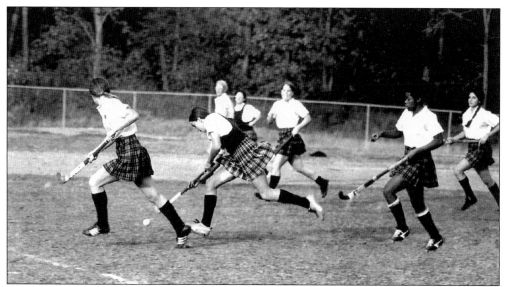

For three decades, field hockey has been an exciting part of women's sports. In 2000, the team made its first NCAA Division III playoff appearance and, in 2003, played in its first Eastern Collegiate Athletic Conference championship game. Although losing to Ursinus by a 1-0 score, the team had a fine season and set a school record for victories (16-5).

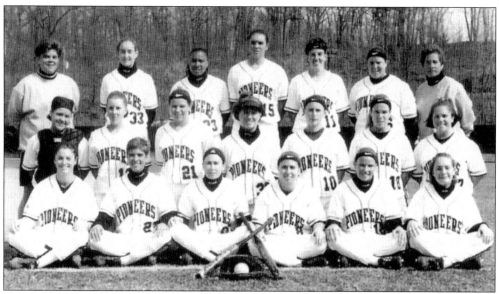

Since 1998, when it received the first of four NCAA postseason invitations, the softball team under coach Hallie Cohen has been impressive. The 1999 team (shown) had a 30-16 season and won its first NJAC title, a feat repeated by the 2003 team (29-12-1). The 2001 team (39-0) won the NCAA East Regional Championship.

Paterson Normal School had a men's soccer team from 1929 to 1934. When the sport was reactivated in 1959, James Houston coached the team until 1963, when Will Myers took over. The 1973, 1975, and 1977 teams won New Jersey State Athletic Conference titles. Since 1991, under coach Brian Woods, the team has had three consecutive winning seasons: 1995, 1996, and 1997.

Since 1997, the women's soccer team, under coach Keith Woods, has posted winning seasons, amassing a total of 90 wins through the 2003 season. In both 1997 and 1998, the teams achieved national ranking and received invitations to the NCAA Division III playoffs both years, including reaching the Sweet 16 in 1997 and winning the NJAC title in 1998.

Under coach Ed Gurka—now completing his third decade as coach and approaching 500 career wins including Metropolitan Conference Championships—a remarkable array of talented athletes has competed on the men's and women's swimming teams, including 19 selected for All-American honors.

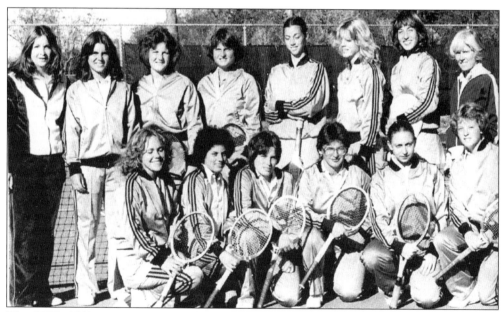

The 1970–1987 tennis teams under Prof. Virginia Overdorf (standing right), National Coach of the Year in 1984, never had a losing season. Nationally ranked several years in the top 10, the team often won local tournaments and played in consecutive national championships. Although discontinued in 1989, women's tennis became active again in fall 2004.

Over the years, the men's and women's track-and-field competitions have produced many notable individual and team achievements. Special mention goes to Rob Hargrove, who took the 2002 NCAA 200-meter national title under coach Horace Perkins.

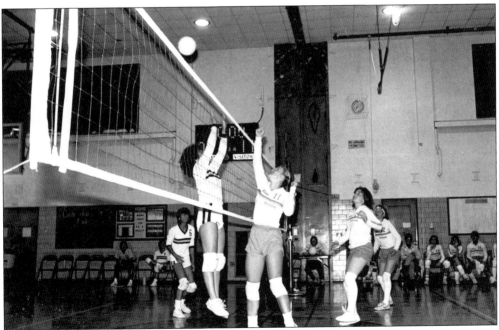

Sandy Ferrarella has coached the volleyball team since 1979, amassing a 422-277 record through 2003, with just three losing seasons in 25 years. Teams won three conference championships (1982, 1983, and 1991) and two New Jersey City University Tournament championships and recently reached the NJAC Tournament semifinals three times (1995, 2002, and 2003).

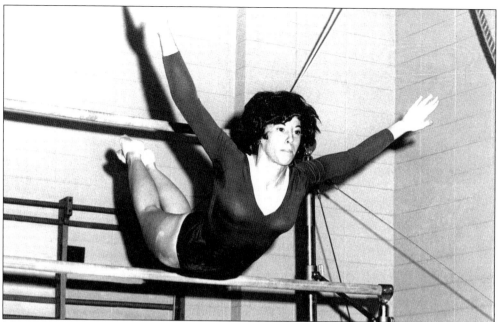

In the 1970s, the college fielded a club gymnastics team, whose difficult schedule included competing against more experienced teams including Princeton, Brooklyn, Hofstra, and the University of Maryland. Nevertheless, the women gymnasts defeated about one third of the opponents they faced.

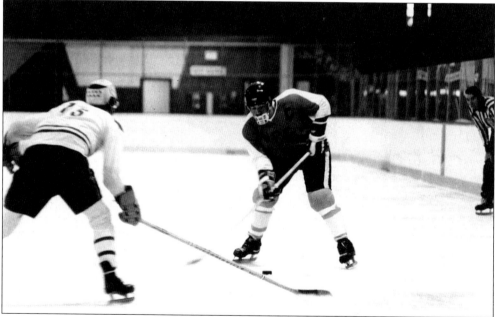

Ice hockey began as a club sport in 1973, when student coach Bob Rodgers led the team to a 7-10-2 first-season record. Now playing at Ice Vault Arena on Barbour Pond Road near 1600 Valley Road, the team in 2003–2004 posted an 8-8 league record in the Mid-Atlantic Collegiate Hockey Association and advanced as far as the first round of the league playoffs.

Seven

COLLEGE LIFE

When the institution was located at School No. 24 in Paterson (1910–1951), students did not have a campus setting. Many extracurricular activities were available, however, to complement their academic pursuits and provide them with a well-rounded college experience—from outdoor ice-skating on local ponds to student clubs, dances, and other social events. Some activities that began during those years continue to draw students today, including the Student Government Association, yearbook, and *Beacon*, the award-winning campus newspaper established in 1936.

After the institution moved to Wayne in 1951, the Student Union building became the college center, followed in the 1960s by the Coach House, which featured a snack bar, bookstore, and student organization offices. The Coach House remained the center for activities beyond the classroom until 1974, with the opening of what is now known as the John Victor Machuga Student Center. Located in the heart of the main campus, the student center houses recreational areas as well as the bookstore, restaurant, and food court.

Over the years, the student center also has served as a home base for student clubs, currently numbering more than 50, offering year-round programming and covering a wide range of interests. Students also can participate in student-run radio and television stations or student musical performing groups and theatrical productions.

Another driving force behind college life over the years has been the university's Greek system, dating back to 1933 with formation of the Skull and Poniard fraternity. Members of the university's 22 current fraternities and sororities participate in diverse activities such as collecting food and clothing to help the less fortunate, organizing special events for campus entertainment, and attending leadership programs.

In 1962, the opening of the institution's first residence hall heralded a new era in campus life. While the majority of William Paterson students historically have commuted to classes, the number of students wanting to reside on campus has increased dramatically since then. Today, the university offers eight residence halls with a capacity for 2,300 students and plans for additional residence halls are well under way to meet the growing demand for a college life that includes on-campus housing.

Whether commuting to or residing on campus, William Paterson students are part of a close-knit community with access to a wide range of social and recreational activities and a wealth of cultural opportunities ranging from art exhibitions and lectures by world-famous speakers to professional concerts and theater productions. College life, however, is more than involvement in activities. It is also a sense of place and an absorbing of the collegial environment. It is studying in the library, exercising at the Rec Center, walking across the campus grounds, eating at a favorite locale, meeting friends for conversation, or just hanging out somewhere. It is, thus, the totality of all campus experiences.

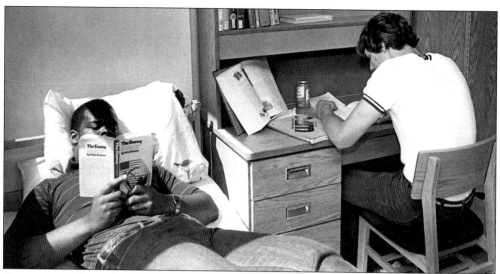

One aspect of residence life is sharing living space quietly so each can read, study, or write assignments in close proximity without disturbing one another. Besides providing an environment for learning how to develop a compatible relationship with another person, room sharing also allows for friendships to form and other viewpoints to be learned.

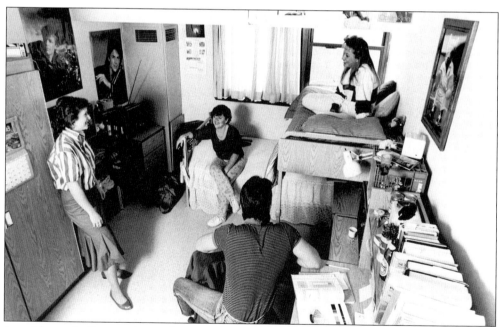

A residence hall room is much more than just a place to study and sleep. It is also an in-person chat room, whether for only a few minutes or for lengthier visits. Friends or neighbors down the hall or from another floor or dorm can drop in and feel welcome, and the resulting social interaction contributes to a richer college life and sense of belonging.

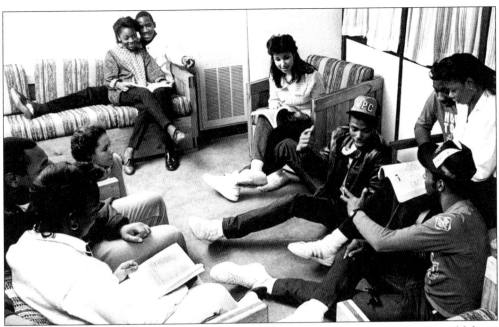

Lounges enable larger groups of students to congregate and interact. It could be a meeting or other planned activity or unplanned happenings such as watching television together or other informal social group activities. Fellow residents are part of the local campus community, and numerous shared interactions create group identity and bonding.

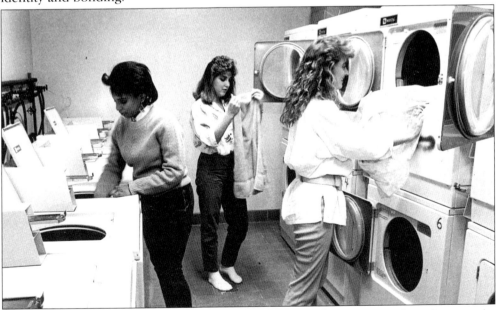

On your own without the built-in maid service from home means learning to take care of yourself. Laundry is just one dimension of gaining self-reliance, but it is a necessary learning experience. Many parents can testify to the fact that their children exhibit a new maturity when they return home from campus, and laundry is part of that process.

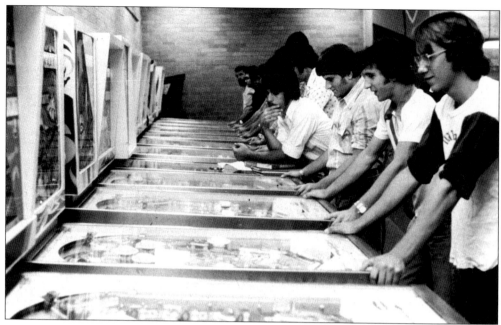

Concentration is a necessity not only in class or when reading and studying but also in playing video/pinball games. One of many leisure-time diversions in the student center, the games let students hone their skills in mastering the intricate interplay of bumpers, flippers, and reflexes in developing that special touch in the quest for ever higher scores.

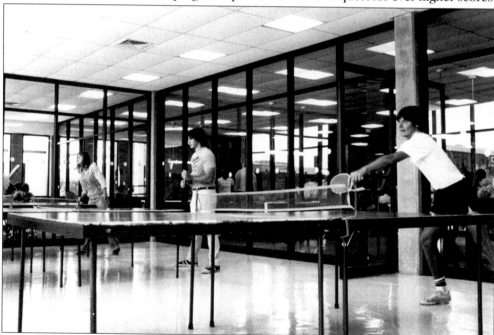

Ping-Pong games continue to be a popular pastime for many students. They can be impromptu fun with friends in the arcade on the lower level of the student center, late-night residence hall challenges in the Rec Center for the Midnight Madness prizes, or serious competition in an organized tournament at the Rec Center.

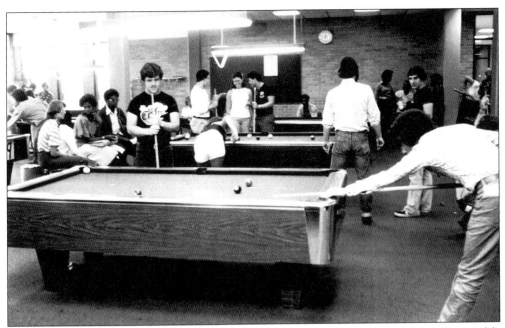

Hobart Manor may have a billiards room, but these days that historical showplace yields to the student center arcade. There, 15 billiards tables offer opportunities for students to use applied geometry to find the correct angle to sink the ball. An annual tournament and a billiards club offer competitive action for more dedicated players.

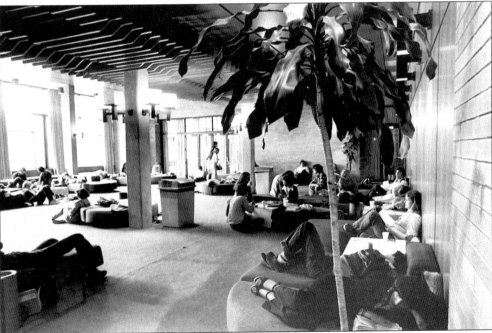

Also in the student center is the gallery lounge, which is often a site for art exhibitions. It is a quiet and restful place, unlike so many other parts of the building, which are filled with activities and/or the din of music and multiple conversations. For that reason many students seek it out to relax and unwind or to study in a comfortable chair.

Billy Pat's, another student center attraction, was the scene of many scheduled and open social functions and available only to members of the campus community. During the day it was a place for food and drink, with wide-screen televisions to watch. At night it offered more, with its high-energy nightclub setting, DJ, live entertainment, and dancing.

Outside the student center, there is often some recreational activity to be found. Most popular pastimes here are Frisbee tossing and touch football. Observing the action or just people watching are the most popular passive activities. Clusters of students often gather in this area to catch some sun, share time with friends, and talk about almost anything.

In the main dining area of the student center, commuter and resident students alike often sit down to consume the food and drink purchased at the adjacent food court. Banners in the background denote the turf of student organizations where groups congregate, while unaffiliated students gather in other sections to eat, drink, read, or chat.

This *Beacon* editorial cartoon humorously depicts the one-time reality of students having to take the long walk from the amphitheater-style parking lot by the Rec Center to any other part of the campus. Frequently running shuttle buses now transport students, not only from Lot 6, but also to and from all parts of the extended campus.

Each season brings different kinds of outdoor activities to the university. A favorite fall event is Homecoming and Family Day Weekend. Although each year is unique, the activities usually include a parade with floats (the 1995 SGA float is depicted), a fair with food and games and activities, a football game, and evening entertainment.

Among the many winter activities, perhaps none are as enjoyable as after a snowstorm, when the hill between the Towers and Parking Lot 7 invites a return to the childhood joy of playing in the snow. Shrieks of laughter often accompany the students navigating down the hill, alone or with others, on plastic bags, lids, or other ingenious devices.

With the milder spring weather comes the annual Springfest, now known as Musicfest, usually held in late April (1988 scene shown here). Groups across the campus help organize a fun week filled with picnics, entertainment, games, giveaways, shows, and novelties. In a 2003 *Pioneer Times* survey, graduating seniors named Musicfest as their most enjoyable campus event.

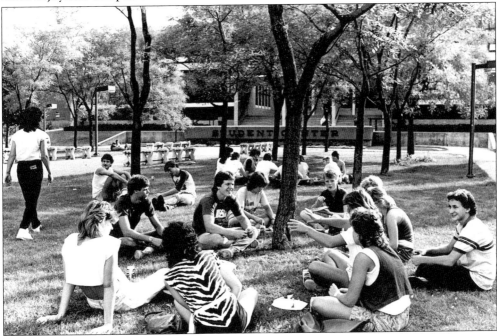

Summer brings a different feeling to the campus. Some students remain to catch up or accelerate their program of studies, joined by hundreds of visiting students from other schools. The outdoor campus scene, when the weather is not too hot, is often of individuals or small groups relaxing in some shade.

Diversity on campus partly manifests itself in student organizations, with the four on these pages representative of all others. The Caribbean Student Association (CARIBSA) reflects the growing number of students from that part of the world who join to share in issues of specific concern to them and to provide support for relevant activities.

The Feminist Collective provides a forum for addressing feminist issues as they impact students' lives within a safe haven where individuals can express themselves freely, without fear or judgment. Open to the campus community, it sponsors speakers and performances among its many activities to promote awareness and solutions.

The Organization of Latin American Students (OLAS) is active throughout the year in numerous events of special interest to its members. A particularly busy time occurs in October with the celebration of Latin Heritage Month, during which members provide ethnic foods at their annual luncheon and organize many other related activities.

Accounting for seven percent of all students in 2004–2005, Asian students are an important element in campus life. The United Asian Americans Club helps interested students pursue activities and concerns of particular relevance to their needs and organize events to celebrate Asian Pacific Heritage Month each May.

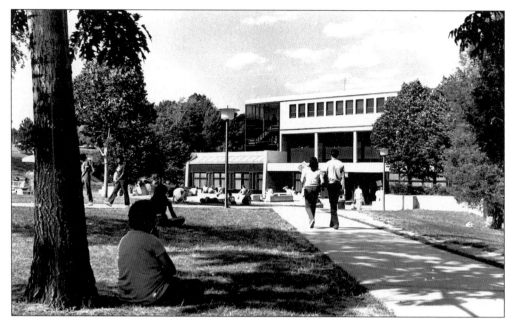

The many sidewalks and trees throughout the campus enable students to find a quiet spot—in shade or sun, depending on one's preference—to meditate, study, or engage in the most popular pastime: people watching. Such peaceful times are seldom written about in a catalog or yearbook, but for many they are a welcome part of campus life.

Enjoying the view outside the second-floor dining facility of the student center, students look out on Caldwell Plaza, which adjoins Ben Shahn Center for the Visual Arts, Science Hall, the student center, and the Towers. The plaza was named after William E. Caldwell, a Pulitzer Prize–winning journalist and former chairman of the William Paterson College Board of Trustees.

Near the end of the academic year, most academic departments hold an annual dinner for installation into a national honor society, giving official recognition to their most outstanding student majors. Recipients typically receive a certificate and honor cords to wear at commencement. Friends and family usually share in the special event, such as this one, the Alpha Kappa Delta dinner held at the Brownstone Restaurant, with sociology chairperson Vincent Parrillo presiding.

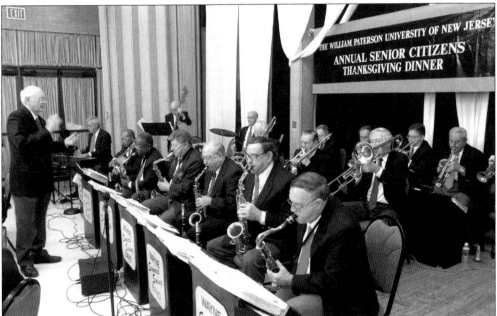

As part of its community outreach effort, the university sponsors the annual Senior Citizens Thanksgiving Dinner, helped by more than 150 faculty, staff, and student volunteers. Besides the food and entertainment, the university presents a lifetime achievement award to a senior citizen who has made a significant contribution to the community.

In its first years, the university held only evening and Saturday classes, and today, those scheduled classes appeal to many students at both the undergraduate and graduate levels. Although many only think of the institution in terms of its daytime classes and activities, almost one out of five students now attends classes at night or on weekends.

At night the campus takes on a different look, both in terms of its visual appearance and in the composition of its student body. On average, students in evening undergraduate classes have a higher median age, work full-time, and/or have home responsibilities. Along with graduate students, most of them concentrate on academics, not on college social activities.

Eight

PROGRESS AND PROMISE

Shakespeare once said, "What is past is prologue." That statement easily applies to William Paterson University, for as dramatic as the achievements of its first century and a half, few would challenge the assumption that its best years are yet to come. A forward-thinking administration and faculty have already set in motion preliminary plans for the further advancement of the institution.

President Arnold Speert and his administrative team are leading a comprehensive campaign—Affecting Lives-Shaping Worlds—to raise tens of millions of dollars to support scholarships, faculty, program initiatives, and new facilities. On another front, more than 350 administrators, faculty, staff, and students have offered their ideas, concerns, and suggestions as part of a master planning process. Out of this evolved a new facilities master plan that will accommodate the university's current and future needs as a vital regional university.

Construction on the first project—the $40 million renovation of the John Victor Machuga Student Center, renovation of Wayne Hall, and the building of a new ballroom in the space between the two structures—began in July 2003 and will be completed in 2006. These renovations, expansions, and construction projects will enable the institution to satisfy the wide-ranging needs of the campus community.

To meet an increasing demand for on-campus housing, the master plan calls for six new residence halls: one 184-bed and one 188-bed facility to open in autumn 2005, with two similar buildings scheduled to open in autumn 2007, followed by the final two in 2009. All will be located near the Towers, Hillside, and Century Halls, thus creating a residential village. In addition, the campus perimeter road has been rerouted to bypass the student housing area, thereby diverting traffic away from the student residence halls.

Other projects detailed in the master plan include a revitalization of Science Hall, a renovation of Shea Center for Performing Arts, and an enhanced Rec Center to meet the demands of the university's rapidly growing student body.

Meanwhile, Chernoh Sesay, provost and executive vice president, and his administrative team are leading a multifaceted operation to advance further the academic quality of the curriculum by implementing an assessment review process and institution-wide Student Success Plan, as well as nurturing the creativity of faculty and staff through incentive, travel, and research grants. Other initiatives—expanding the University Centers, international education, and technology in the classroom and initiating recognition awards for scholarship, teaching, and service—contribute to an environment in which the motivation to excel is a paramount objective.

The following pages illustrate the more recent advances in the university's continuing expansion. The book closes with a reminder of each chapter in the university's past, present, and future: the year beginning with new freshmen arriving and concluding with seniors graduating.

Hillside Hall (pictured) is next to the Towers and houses 254 students. Century Hall, a 280-bed residence hall, opened in 2000, bringing total residential capacity to nearly 2,300. All three will be part of a larger residential village, with the construction of new nearby facilities throughout this decade.

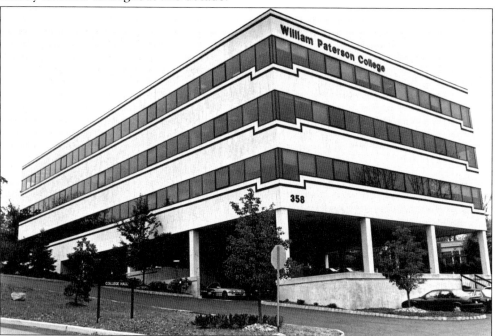

College Hall brought institutional visibility to the heavily traveled Hamburg Turnpike. Located here are the offices of the vice president for Administration and Finance, Business Services, Bursar, Human Resources, Institutional Research and Assessment, Payroll, Purchasing, Registrar, Telecommunications, and Marketing and Public Relations.

In 2003, the university dedicated the Allan and Michele Gorab Alumni House at Oldham Pond, North Haledon. The building houses the Alumni Relations Office and the John Rosengren Laboratories, named after the late professor emeritus of biology. The Bayer Corporation in 1998 donated the 26.5-acre site, including the house, pond, and wetlands.

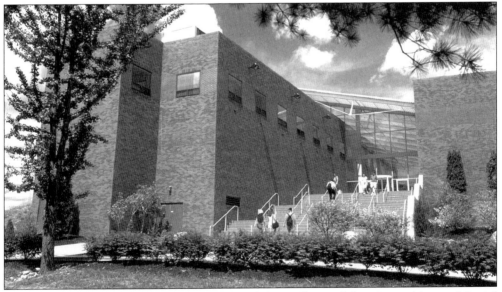

The Atrium houses the office of the Dean of the College of the Humanities and Social Sciences and the Departments of African, African American, and Caribbean Studies; English; History; Languages and Cultures; and Philosophy. Also located here are the offices of Instruction and Research Technology, as well as public access computer labs, language labs, the writing center, and a multimedia auditorium.

Older alumni might have difficulty recognizing the old laboratory school (Hobart Hall). Expanded by an additional 25,000 square feet, it is now a state-of-the-art home for the Communication Department, housing two radio stations, the cable television center, the interactive teleconference center, electronic journalism labs, an interactive television classroom, other classrooms, and the film production and screening facilities.

The Power Art Center, located near College Hall, accommodates a variety of studio arts. Its extensive facilities contain the offices for faculty and the dean of the College of the Arts and Communication. Also here are studios for ceramics, painting, photography, printmaking, sculpture, three-dimensional design, and woodworking.

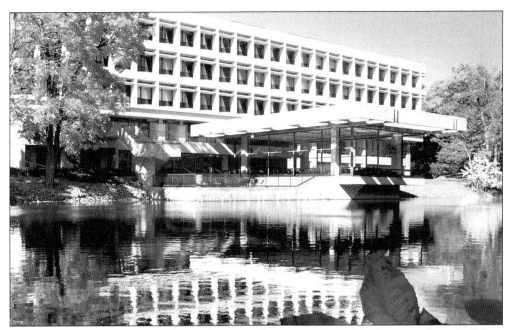

In 2002, the university dedicated its newly acquired 150,000-square-foot building located on 50 acres at 1600 Valley Road, increasing its academic facilities by 25 percent. The building is the new home of the Christos M. Cotsakos College of Business, the College of Education, and the Center for Continuing Education and Distance Learning.

To be completed in 2006, the student center-Wayne Hall project includes renovation of the buildings, new entrances, and a three-story addition to the student center. A new building linking the two will contain four meeting rooms, storage and dining service rooms, and a 500-seat ballroom on the upper level. Wayne Hall will receive a new facade and will contain storage and dining service rooms and a new university club.

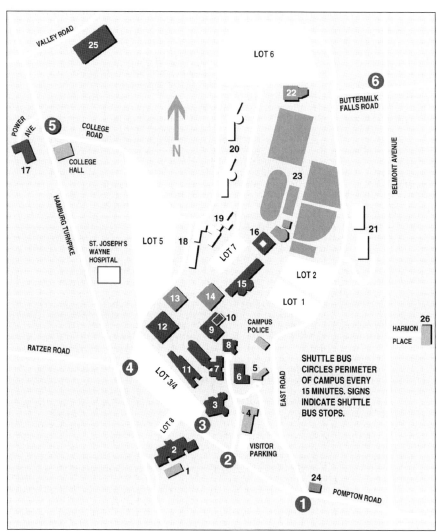

This map shows the present-day number and location of all academic, administrative, and residence buildings. Four of them—College Hall, the Gorab Alumni House, the Power Art Center, and 1600 Valley Road—are on sites detached from the main campus.

1. Admissions Hall
2. Hobart Hall
3. Shea Center
4. Morrison Hall
5. Hobart Manor
6. Raubinger Hall
7. Hunziker Hall
8. Coach House
9. Wightman Gym
10. Pool
11. Atrium
12. Cheng Library
13. Wayne Hall

14. Machuga Student Center
15. Science Hall
16. Ben Shahn Center
17. Power Art Center
18. White and Matelson Halls
19. Towers
20. Hillside and Century Halls
21. Pioneer and Heritage Halls
22. Rec Center
23. Athletic Fields
24. Catholic Ministry
25. 1600 Valley Road
26. Gorab Alumni House

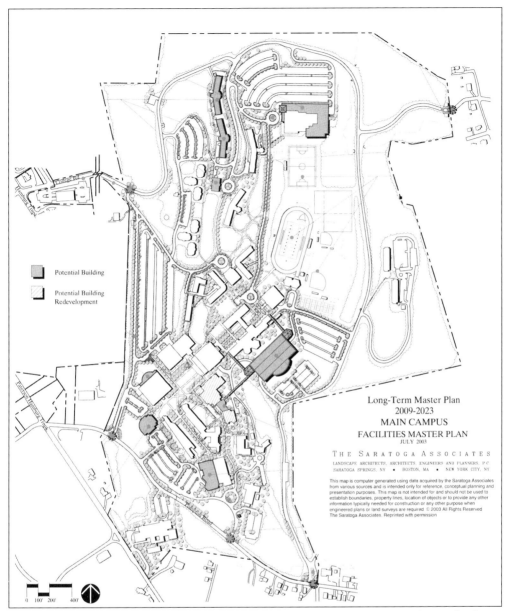

Long-Term Master Plan
2009-2023
MAIN CAMPUS
FACILITIES MASTER PLAN
JULY 2003

THE SARATOGA ASSOCIATES

LANDSCAPE ARCHITECTS, ARCHITECTS, ENGINEERS AND PLANNERS, P.C.
SARATOGA SPRINGS, NY ■ BOSTON, MA ■ NEW YORK CITY, NY

This map is computer generated using data acquired by the Saratoga Associates
from various sources and is intended only for reference, conceptual planning and
presentation purposes. This map is not intended for and should not be used to
establish boundaries, property lines, location of objects or to provide any other
information typically needed for construction or any other purpose when
engineered plans or land surveys are required. © 2003 All Rights Reserved
The Saratoga Associates. Reprinted with permission

Potential Building

Potential Building
Redevelopment

0 100' 200' 400'

With the legend on the opposite page to identify buildings, this map shows the long-range facilities master plan for physical development of the main campus. (As implementation proceeds, detailed zone plans with more precise building forms and locations will be developed as terrain and funding allow.) In the upper left is rerouted College Road, with new residence halls incorporated into a larger student residential zone that includes Century and Hillside Halls and the Towers. Also shown are additions to the Rec Center and Science Hall and Shea Center, a new parking structure behind Science Hall, new pedestrian paths, and improvements to all gate entries, to provide a unified sense of campus arrival.

Moving into the residence halls at the beginning of freshman year is a time of eager anticipation and nervous excitement. New commuter students may not go through such a dramatic change in living conditions, but their first day of college sparks similar feelings. Each year, the story begins again for a new entering class on the road to higher education.

Each year, the story ends again for another graduating class. Elation at commencement joins pride in earning an academic degree. With new excitement, each graduate faces the future, supplemented by the knowledge and skills acquired during his or her college years. Although William Paterson University becomes a memory, one's thoughts often return to it.